Praise for *Chain-ged: Finding Freedom in Christ through Poetry, Principles, and Prayer*

⸺◉⸺

"I love *Chain-ged: Finding Freedom in Christ through Poetry, Principles, and Prayer* by Casey Cassady. It is a special gift to help women gain the healing they need, all while ending the identity crisis so many of us have or had. The structure of the book makes it easy to navigate as well. The poems open you up to receive, the principle gives clarity, the prayer activates God and the angels to respond, and the practice helps the reader dig deeper, and to really uncover those dark places. I would recommend this to all women, and even some men, who need a self-help guide on gaining oneness with Christ."

> — Jennifer Mason, Founder of *"Single Lady Notes"* on Instagram, Author of *Good Girl, Gone Bad, Gone Holy*

"From the time I have had the honor of connecting with Casey, I have observed that she has a unique grace on her life. That grace is needed in this season of our lives. One of the most important elements of life are words. Words bring a season to an end and words usher in a new beginning. To the Believer, words are everything, and their words get their power from the Word. Casey has the ability to put words together so that they become weapons and tools that may be used to win wars or build worlds. Read and experience a divine release in every aspect of your life."

> — Dwayne Thomas
> Speaker, Pastor, Entrepreneur

"Casey Cassady is a beautiful young lady with a beautiful heart and soul. Her spirit is filled with the precious fruit that can only come from the Holy Spirit, for every good and perfect gift comes from above. Casey is a gift to the body of Christ. Her heart to see the captives set free comes from a genuine place. Her anointed writings are not about hurt and no help, but rather in spite of the deep dark places of pain and disdain, the love of Jesus and the power of the Holy Spirit to heal, set-free, and deliver is available for every person.

Chain-ged: Finding Freedom in Christ through Poetry, Principles and Prayer is an anointed work likened unto that of the Book of Psalms, a real-life compilation of writings which became scriptures that are rhema words of poetry, principles, and deep prayers written from deep places of vulnerability, yet trust in the Lord and His glorious power. Open your heart to be chain-ged, which is only available in Christ Jesus."

— Prophetess Leticia Lewis
Majestic Ministries International

"*Chain-ged* is beautifully written, an honest display of God's love for us through poetry. It's an uplifting work of encouragement for every soul."

— Pastor Dawn Adams, Founder,
Women Who Pray Ministries,
Zion Girls Academy
Selaphiel Resources Group

"Casey Cassady is a woman who has been a living example of her writings and teachings. At a time when our Christian walk has been largely intellectualized, while our emotions and artistic creativity is discarded as being of little or no use in our worship of God, this book invites us to the rich experience of worshipping the Lord with all of our being—body, soul, and spirit. This book deeply touches the heart,

and has fascinated, enlightened, and greatly encouraged me while it undoubtedly flows of a fiery passion.

The incredible combination of poetry, prayer, and powerful scriptural declarations in this book really help you to understand God's plan, while keeping your heart and mind focused on Him! I highly recommend this book as a tool that will help you step into your purpose in the Lord and your identity in Christ. What an awesome book—a well-written must-read!"

> — Indira Newallo, Co-Senior Pastor
> The Apostles Ministries
> Londenville Chaguanas, Trinidad and Tobago

"There are writers and there are authors. Casey Cassady is beyond both. The way she expresses herself when she writes literally takes her readers on a journey of her life, which only an author, writer, and realist can do. If you are ready for the ride, I recommend this book for you and those in your life."

> — Pastor AJ Johnson, MBA
> FaithPointe

"Casey Cassady has written a must-read for any woman who struggles with self-worth and needs to find her identity in Christ. I love the way Casey masterfully uses poetry, biblical principles, personal experiences, and prophetic prayer to bring hope and healing to the reader."

> — Roberta Frazao
> Author of *The Endurance of Faith*

CHAINGED

Finding Freedom in Christ through Poetry, Principles, and Prayer

CASEY CASSADY

THE SOPHOS GROUP

CHAIN-GED: FINDING FREEDOM IN CHRIST THROUGH POETRY, PRINCIPLES, AND PRAYER

Copyright © 2021 by Casey Cassady

Published by The Sophos Group, Lincoln, CA 95648. All rights reserved. For more information about this book and the author, please contact:

Email: info.cassadycassady@gmail.com
Facebook: @FindingFreedomInChristBook
Instagram: @findingfreedominchrist or @caseymaecassady

Edited by:
Jennifer Edwards, jedwardsediting.net

Cover Design & Book Typography by:
Linné Garrett, 829Design.com

Cover Photo by:
Devin Bovee Photography

ISBN hardcover: 978-1-7327564-5-8
ISBN paperback: 978-1-7327564-6-5
ISBN ebook: 978-1-7327564-7-2

PRINTED IN THE UNITED STATES OF AMERICA

I wrote Chain-ged as a platform of encouragement
to help women of all ages find hope, healing,
and wholeness as they discover their identity in Christ
through testimonial poetry, biblical principles,
and prophetic prayer.

*His light broke through the darkness and he led
us out in freedom from death's dark shadow and
snapped every one of our chains.*

— PSALM 107:14 (TPT)

· CONTENTS ·

My Eternal Gratitude

T HE COVER OF THIS BOOK may have my name on it but there are many people who deserve recognition for the existence and release of this book being possible.

Thank you, Dad and Mom, for being two of the strongest, supportive, and most unconditionally loving people I know. Thank you also to the rest of my family, especially my brother-in-law and sister, Ricky and Caley Snow, for contributing towards me and this book in your own ways as well.

Thank you to my close friend, Heather Montoya. You are an example of the love that should exist in every friendship. You have been by my side these last ten years in ways that no other person has. Thank you for our friendship and for always encouraging me to succeed in my career as an author. You are truly my "soul sister" and having you in my life is one of my greatest blessings.

Thank you to Jessie Mc Barrow (aka JWVE). You have consistently inspired, encouraged, and challenged me. You have taught me about godly vision and taking respon-sibility over godly assignments. Thank you for showing

me in countless and profound ways that you believe in my calling and in the success of this book. Additionally, your work ethic and ambition as a talented musician continues to inspire me on this journey. I can genuinely say that I could not imagine being where I am spiritually or as a woman living in purpose without your willingness to be used by God in my life.

Thank you to Pastor Dan Chrystal, founder of The Sophos Group and my publishing mentor. You have kind-heartedly, wisely, professionally, and spiritually helped me so much throughout my publishing journey.

Thank you to my dear friend, Derricka Elwood. Your sweet and wise spirit has been admirable since the first day we met. I remember when we were in prayer one day and God used you to prophesy that this book would be filled with my poetry. Thank you also for introducing me to Pastor Dan when I was ready to find a publishing company. These are just a few of many reasons why I cherish you and our friendship. You are amazing.

Thank you to those who donated financially toward the publishing of this book:

Ricky and Caley Snow
Bryan Davis
Jennifer Gong
Amanda Lane
Angela Morita
Janan and Kristen Hannah

Thank you to each person who participated in my focus group, read the first draft of this book, and provided me with valuable feedback, critique, and encouragement:

Pastor Monica Kirkland
Jose Luna, M.Div.
Frances Wise, Ph.D.
Ms. Alicia Gunness
Mr. Robert Taylor
Ms. Asha Jagdeo
Pastor Anthony "AJ" Johnson

And lastly, thank you to each person who did me the honor of providing an endorsement. I know it took time, and I appreciate you.

Prophetess Leticia Lewis
Pastor Dwayne Thomas
Pastor Indira Newallo
Pastor Dawn Adams
Pastor AJ Johnson
Ms. Roberta Frazao
Ms. Jennifer Mason

So as I sat there expired, I was officially drained.

And at that point in my life,
my only desire was to find eternal change.

Because being expired no longer received my agreement.

This was the title placed upon my flesh
when God spoke to me "leave it."

I've been brought to a place where I choose freedom
rather than captivity.

I choose for my arms to be lifted in praise,
rather than chained.

I choose God's Kingdom over
world-founded plasticity;

and for my heart to be shifted
because of who reigns.

There is so much to press forward to

and so much wisdom to gain.

So I continue on seeking the light
shining over my pain.

Change Begins Here

HELLO, BEAUTIFUL SOUL...

I am thankful you have chosen to read this book. I have been praying that by reading *Chain-ged*, your entire life will...well, change. The poetry, principles, and prayers written in each chapter of this book capture specific "roles" of who God is to us. As God's daughter, He is 100 percent involved in every part of your life. When you become aware that the God who created you knows everything about you, can meet every need you have, love you in ways no one else can, and help you through every life experience, you can truly live in the abundance you've been called toward.

Along with each role-focused chapter, there is a testimonial poem, a biblical principle, a prophetic prayer over you, and a practice section. Most of the poetry is written from a third-person perspective but is also my personal testimony. My desire is for you to find hope, inner-healing, and wholeness from the following things:

1. Identifying with the girl in the poetry (who happens to be me);

2. Learning from the principles;

3. Declaring and decreeing the prayers over yourself;

4. Becoming more self-aware of areas that need healing through the practice questions;

5. Discovering your God-given identity;

6. Living fully in your purpose.

Being a woman who, through Christ, has overcome a lifestyle of partying, alcohol, promiscuity, toxic relationships, rejection, shame, guilt, regret, and probably anything else you can think of, I think of my past and only wish I would have had access to a book like this. I believe and hope that by reading it, God will help you find your way out of the brokenness and bondage you were never designed for as you begin to live a deeper revelation of who you are and the beautiful future ahead of you.

The process of healing and growing more into who God has intentionally created you to be is not an easy journey but I can promise you this:

The more you are able to surrender to God and
allow Him to transform your mind, your heart, and,
ultimately, your life, every step forward with Him, the
good and the not-so-good, will be worth it in the end.

Soon, you will find yourself having to make a choice. You can choose to either continue down a repeated cycle of brokenness that only leads to destruction, or you can choose to allow God to raise you into the daughter He calls you to be (Isa. 60:1). Let Him take your hand, guide you with His counsel, and lead you into your glorious destiny (Ps. 73:23-24). May you ultimately encounter the freedom you are thirsting for in this season of your life by calling out to God.

~ Casey

God Is Father

And because we are his children, God has sent the Spirit of his Son into our hearts, prompting us to call out, "Abba, Father."

— GALATIANS 4:6 (NLT)

The Poem

"Father Figure"

BY CASEY CASSADY

Forty years, they've been married;

their love truly exists but was often times buried

Under a mind-altering life of one person
who carried a love on the side.

He's chosen to drink although was still
able to financially be a provider

But emotions and time were never included
– between them, there was a divider.

Because upon his arrival at home,
his mind couldn't stay sober
and before he knew it, he'd wake up
and the day was already over.

The girl's mother was hurting, but was strong
because she knew her man all along
before times began to get lower.

But that young girl had vague memories
of what her dad was like as a father
without a bottle in one hand, and
work phone in the other.

And throughout her life she wished that she
at least had a brother a little bit older
so she could depend on a man to help guide
and help mold her.

Her mom did her best for that young girl
who was still just a kid.

While the father fought for his family – I promise he did.

Through facilities, and rehabs, and meetings,
all so he could say "goodbye" to addiction
rather than "greetings."

⌒

And eventually, the light of freedom
and grace pierced into
his heart and cut all the way through.

This man of God was given a chance to start new.

The process of a family restoration was
only something God could do;
and he thanked the Lord that his daughter grew
into a woman who believed in the Truth;

she didn't judge him at all but prayed for her daddy
from the days of her youth.

And although the healing process was tough,
his marriage began to get stronger.

His wife and their loved ones forgave him, even though they
noticed how much his addiction had wronged her.

⌒

And as he began a process of fighting
for sobriety-consistence,
another being was affected in this story and that
was his daughter – his princess.

You see, she didn't have a relationship with Jesus
until many years later,
and with a father not able to teach her about
the heart of the God who had made her,
she had to learn on her own:
how to become a woman;
how to become properly grown.

But for many years, she found herself
on a path of destruction.

She had been pulled into a lifestyle of darkness
by a world-colored suction,
and even in moments of not knowing why
she made the decisions she made,

The truth is that she had always suffered rejection;

"people-pleasing" was her forté

and she was so good at it,

she could have won an election.

But God brought her to a place in her life where she knew
she could no longer find other people to blame.

As she takes responsibility for herself,
she wears the Armor of God;

for in the Lord she is strong; she is no longer the same.

She can't dwell on the past, but what she can do
is learn and move on.

Because God the Father says she's forgiven
from everything she's done wrong.

And he sings to her, the sweetest of songs.

He teaches her things, that she wishes
she'd known all along.

His Grace makes that okay, it's a new day
with a sunrise and it's barely past Dawn.

And he gives her His Spirit in exchange
for the losing cards she's been dealt.

Because one glance of her being officially made
her Heavenly Father's heart melt.

He heals every moment of pain, every cut, every bruise.

Deep down to the parts of herself
that were often abused.

He protects her from harm,
and gives her much wisdom as she reads and
declares the words from His lips.

She's never had a Father so warm.

She's never had a Father like this.

© Casey Cassady 2019

The Principle

God designed sexual intercourse and the process of reproduction to be within a healthy, lasting marriage. It is a harsh reality that there are millions of children who grow up without a father, either physically or emotionally. According to a 2018 Pew Research study, 24 million U.S. children younger than eighteen are living with an unmarried parent. Most (15 million) are living with a solo mother.[1] That is a lot of fatherless kids.

I know that sounds hopeless, but the good news is that God is a Father to all of us; in fact, He's the greatest Father anyone could ever have. At His core, He has the very heart of a father, one who cares so deeply for you that He went to incredible lengths just to be with you.

He pursues you...
 He woos you...
 He genuinely loves you just as you are.

God wants you to know the depth of His heart and to have the capacity to enjoy Him and need Him in ways you may think only an earthly father could be needed. He wants to be involved in your life, not just someone who is looking down from heaven, disinterested, unattached, somewhere high above us. Seeing God as our Father goes beyond a prayer that starts off with "Dear Heavenly Father." The Bible says this about God as Father:

*"The LORD is like a father to his children, tender
and compassionate to those who fear him."*

— PSALM 103:13

*"And because we are his children, God has sent the
Spirit of his Son into our hearts, prompting us to
call out, 'Abba, Father.'"*

— GALATIANS 4:6

*"So you have not received a spirit that makes you
fearful slaves. Instead, you received God's Spirit
when he adopted you as his own children. Now we
call him, 'Abba, Father.'"*

— ROMANS 8:15

*"Do not be afraid, for I have ransomed you. I have
called you by name; you are mine."*

— ISAIAH 43:1B

*"Even before he made the world, God loved us and
chose us in Christ to be holy and without fault in his
eyes. God decided in advance to adopt us into his
own family by bringing us to himself through Jesus
Christ. This is what he wanted to do, and it gave
him great pleasure."*

— EPHESIANS 1:4-5

Aren't those beautiful words? God is delighted to adopt
you as his own, as a daughter full of beauty, full of strength,
full of dignity and grace. If you did not serve importance
and a purpose on this earth, God would not have chosen

to create you! You are fearfully and wonderfully made, according to Psalm 139:14 (AMP), which says, "I will give thanks and praise to You, for I am fearfully and wonderfully made; Wonderful are Your works, and my soul knows it very well." Your Father God unconditionally wants you, accepts you, and loves you as His beloved daughter no matter what messes you have been in or mistakes you have made.

If you did not serve an important purpose on this earth, God would not have chosen to create you!

Even if you have had a great earthly father in your life, nobody other than God is perfect. Letting God into your life as Father means you have accepted His free gift of salvation—you have chosen to believe in His Son, Jesus Christ, through faith, believing that He died for your sins and for your life. When you've done that, God adopts you as His own.

As we move further in this book, we'll analyze the impact your earthly father has had on your life, but I want to encourage you to also keep your mother in mind. Everything I encourage you to do to find healing will also apply to your mother. Even the most nurturing or absent mothers have affected their children in some way.

First off, I would like you to get rid of all the lies you have about what a "father" is. They simply do not apply to our Heavenly Father. I have learned and held onto a biblical concept from a sermon series presented by a respected Christian leader, Eric Knopf, when attending a young adults ministry in Sacramento, California, called Epic Life. Eric taught that you cannot perceive the heart and character of

God the Father in the same way you perceive the heart and character of your own earthly father. For example, if your father abandoned you, rejected you, and/or abused you, you must know that God the Father never has and never will do those things. Deuteronomy 31:6 says, "So be strong and courageous! Do not be afraid and do not panic before them. For the LORD your God will personally go ahead of you. He will neither fail you nor abandon you."

At the end of the chapter is a reflection section called "Practice," and I encourage you to think about and write down every negative thought and experience you have of your father and even just the word "father," in general. Think and pray about the voids in your life, areas a father figure was never able to address or take care of. These could be issues of provision, discipline, love, guidance, being able to teach you things that you should have learned while growing into an adult, and so forth. Then compare everything you write down with who the Bible says God is by looking up the Scripture verses provided. I think what you will find is that God is the Father who can fill all those voids and teach you things that are missing.

Reflecting on the imperfections of your own earthly father may seem a bit critical and painful if you are left with only memories you don't want to think about. However, doing this hard work of reflecting will enable you to face the experiences of the human side of your father that need to be exposed so you can deal with and overcome your emotions and false perceptions of who God is and the love He has for you. Furthermore, being able to pinpoint weakness in others, such as your father, doesn't

mean that you are looking at them in a negative way. We are all imperfect people and weaknesses do not necessarily define someone's character or limit their potential to become a better human being.

When the light of truth shines on the darkness of lies, there are opportunities for understanding, healing, and forgiveness. Be aware that when you begin to find freedom, Satan does what he can to cause you to continue believing lies about yourself, about other people, and mostly about

God will completely fight the battles you choose to face— so go ahead and face them.

God, because if you believe lies about God, you will ultimately believe lies about everyone else, including yourself; therefore, you would never be able to truly experience the depth of God's love for you.

Believe me, I understand the pain of facing the truth that pertains to our parents. Their weaknesses, their absence, their lack of communication, not being able to meet our basic needs, or not being able to express their love in the ways we need them to can create pain, mistrust, and feelings as though they don't care. I mean, who wants to think about those things? Trust me when I say you do. I know it's scary and painful, but the sooner you face these thoughts and memories that keep you in bondage, the sooner you will find freedom. The best part is, you don't have to do this alone! God will completely fight the battles you choose to face—so go ahead and face them.

My father may have been an alcoholic, but he is also the kindest, most intelligent, most hard working, and

funniest person I know. I learned throughout the process of his search for sobriety that I could not allow myself to let his addiction define him (or me). He was and is a son of God, and if God could see the many great things about him and his destiny, I knew that I still could as well. When my perspective changed and I was able to see him as a precious son of God, it not only gave me more peace about the situation, but he also found relief in the fact that his daughter did not judge him for being weak in an area of his life. There are so many wonderful things about who my father is, despite the fact that he struggled with addiction. When I realized this, it also gave me the strength to truly forgive him; to be able to wholeheartedly pray for and declare and decree his healing and have faith for his sobriety.

I realized more recently that I had a lot of growing to do in the areas where my father wasn't able to emotionally or spiritually fulfill in my life—mostly with wanting attention, getting guidance, and being disciplined when I needed to be. However, now that I am an adult and have a relationship with Christ, I have a responsibility to not blame my father for this, but to make sure that I allow God and my Christian community to teach me the things I still need to know.

I also must make sure that I do not allow my past thoughts toward my father to affect my relationship with God the Father and how I view Him. For example, even throughout his addiction, my father was still always able to provide for our family. Because of his financial provision, I have always been strong in my faith when pertaining to

God as being a provider. On an opposite scale, because my father was not often able to provide discipline (my mother did her very best), I had issues with decision making and discipline as I grew older. I would continually make the same bad decisions even when God permitted consequences for my actions in order to discipline me. For many years, I did not know how to repent from a lot of my sin because I did not know how to respect the process of discipline.

Once there is a line of differentiation drawn between a father as a human being and our Heavenly Father, our Heavenly Father can begin to heal all of the broken pieces, unforgiveness, bitterness, guilt, and disappointment that you may have felt toward God because of your experiences with how you have felt about your earthly parents. He exposes these feelings so you can turn to Him—a Heavenly Father who is perfect in all ways and provides you with the healing that you truly need in the deepest parts of your soul. This will benefit not only your thought process on who your earthly father is, but it will drastically strengthen your relationship with God the Father because you will begin to trust, love, and understand Him and the heart that He has for you (and the heart He has for your earthly parents) as His precious child.

I hope that at this very moment, you are already beginning to feel like chains are breaking—like a burden is being lifted. Maybe peace is settling upon you. You may not be deserving of all that Jesus did for you on that cross, but now that He already has, because of *His choice to choose you* no matter what you have been through or what you

have done, you can choose Him to play the role of Father in your life that you never have before.

The Prayer

Heavenly Father,

I pray over every woman who has this book in her hands today. I pray that as she begins this journey of healing, seeking true identity, and finding a deepened closeness with you, that she is able to receive you in her life as the Father she has never had on earth. I pray for your love to seep into the deepest parts of her heart, having grace over and covering all brokenness for not having parents who could ever be as perfect as you.

I pray for all voids to be filled, for forgiveness to stream through her tears of healing, and that you begin to refine her. Teach her the wisdom she was not able to be taught; protect her in ways that she was not protected; guide her mind and heart.

Thank you for showing her the true, unconditional, and everlasting love of a Father who is our God Almighty. Open her eyes to a whole new love: the *Love* of a God who sent His one and only Son, Jesus, to a cross for her. I declare and decree that a deep revelation sweeps across her, shifting atmospheres and changing lives forever. I pray for physical, mental, and spiritual healing, and divine encounters

over her earthly families; that addiction, abuse, demonic influences, abandonment, and division are all broken off and destroyed right now, in Jesus's Name.

Thank you, Father! You are nothing but good, and I give you all of the glory.

Amen

The Practice

Prayerfully read over these questions and begin to answer them as honestly as you can.

1. How is my relationship (or lack thereof) with my parents and my personal experience of their parenting, affecting my relationship and intimacy with God?

2. What are some areas of my life, throughout my childhood and as I grew older, that I did not receive from a parent, or both parents, and should have? For example: a sense of safety, love, basic necessities that cost money (i.e., food, shoes, warm clothing), an emotional connection, recognition, affirmation, discipline, opportunities, and so on.

3. After reviewing the Scriptures in this chapter, has your perception of God's role as Father changed at all? Do you see Him as more of a loving Father? Find these Scripture verses in your Bible and write down how they apply to your life. I also encourage you to study them further while you ask the Holy Spirit to reveal their truths to you on a deeper level.

Deuteronomy 31:6

Psalm 103:13

Psalm 139:14

Isaiah 43:1

Romans 8:15

Galatians 4:6

Ephesians 1:4–5

4. What do I need to forgive my parent(s) for? What do I need to forgive God for? What do I need to forgive myself for? How can I now allow this forgiveness to bring me closer to God?

God Is Son

_And who can win this battle against the world?
Only those who believe that Jesus is the Son of
God._

<div align="right">— 1 JOHN 5:5</div>

The Poem

"Son Rise"

BY CASEY CASSADY

Her intentions have always been good,
some days they've been at their prime.

This girl who's naïvety was borderline foolish at times.

Her definition of accepting the heart of another person
was also accepting their behavior.

So she cried through the harsh words, the oppression,
and the dangers that came to her.

And in response to the trauma that she just
couldn't face to find healing,

were thoughts and actions that each disgraced
who within her is dwelling;

and while many years passed, shame and
condemnation hit her like bombs;

until the lights from those explosions began
to expose to her the right from the wrong.

Beauty from those ashes was the demonstration
of the Mercy that was given;

while she studied the Word and learned
of the Lord that has risen.

About how if there had not been Jesus,
the Son of God the Father,

There would have never been a reason for her
to realize that He's called her;

And He desires to love away all of the hurt,
and to show her she's not alone in her troubles.

To cleanse her from the dirt when she's stumbled,
into that hell-hole of a puddle.

She now believes she's forgiven,
so she's able to repent from her sin;

She's thankful for the blood of Jesus on the Cross,
even way back then.

⟶

But despite how long ago that tomb was found empty,
He is with her each day,

she even has dreams He Is next to her, speaking so gently
and helping her stand.

He tells her, "It no longer matters that you've fallen.
It just matters where you land.

I'm here to catch you, my daughter.
There's no reason to be scared.

My love conquers all because it's stronger than flesh,
yet it's lighter than air."

⟶

She looks up to the sky.

And sees a Son rise in the Spirit of her being

and for the first time, her eyes open. She is finally seeing

a realm of Heaven that truly exists,

because of her Faith that believes
what Christ has already done.

She's a daughter of the Most High,
who has already won.

Her entire life changes

because her mind and heart are completely
restored from the doom,

that girl who once faced the den of a lion,
was saved by her Lord;

in Him she's completely consumed;

her fate was no longer a morgue this soon,

God just turned this around because she is now saved

There is a special purpose,
there is a special sound for that girl
who almost got away.

This is her time; this is her day.

The Principle

Another beautiful and true role that God holds is being Jesus, the Christ, God the Father's one and only Son. Accepting God as Jesus Christ certainly takes a bit of faith, but it is the only way to the Father—the very key to salvation, eternal life, and the knowledge of the Love of God. The Son, Jesus, endured everything we go through on a daily basis. And because of the crucifixion on the cross and His resurrection three days later, He paved the way and provides everyone the opportunity to choose eternal life with our Father in Heaven.

John 16:33 says, "I have told you all this so that you may have peace in me. Here on earth you will have many trials and sorrows. But take heart, because I have overcome the world." Jesus was the ultimate sacrifice. He was led by the Spirit of His Father in everything He did, to set an example of what Christians, His followers, should strive for. You are not created to be perfect on earth, for if you were, you would have no desperate need to seek and have identity in Christ. But if your mindset, heart, actions, and lifestyle aligns with Jesus's as much as possible, you can be sure you are on the right path.

Jesus was fully God and endured the temptations and persecutions that everyone does because He was also fully man. He knows what challenges you may be facing and the emotions that go along with those challenges. He died not

only for your sins but so that once He was resurrected from the dead, He could send a comforter to help you through your troubles. John 16:7 says, "But in fact, it is best for you that I go away, because if I don't, the Advocate won't come. If I do go away, then I will send him to you." And John 14:15–16 says, "If you love me, obey my commandments. And I will ask the Father, and he will give you another Advocate, who will never leave you." Jesus dying and rising from the tomb was the only way we could have eternal life in Heaven and an Advocate now, the Holy Spirit, who is also a comforter. (You will be able to read more about the Holy Spirit as an Advocate and Comforter in the next chapter, but my main focus now is the beauty of how Jesus can relate to every part of you.)

...you do not have to live in shame; you are extremely beautiful, loved, and forgiven, and there is so much light in the midst of your darkness.

Since God knows your challenges and hardships, He chose to find a way through the crucifixion of His Son to ensure that every person on earth could relate to Jesus so that they could be assured of never being alone in whatever it is they are going through. I am here today to tell you that you can relate to me, and more importantly, that you can relate to Jesus. In the YouVersion Bible App Devotional called "The Way of the Warrior" by Erwin McManus, he says, "Even Jesus did not want to face his darkest moment alone. When Jesus prayed in the garden of Gethsemane the night before he was to die on the cross, he chose to take three of his closest friends with him."[2] Whether through what you have read so far, the chapters still to come, or conversations we may have if we are to ever cross paths, I

pray that my testimony, and the testimony of Jesus Christ, show you that you are never alone in your circumstances.

I hope that you know that you do not have to live in shame; you are extremely beautiful, loved, and forgiven, and there is so much light in the midst of your darkness. Even if you only see a glimpse of light so far, I declare and decree over you that the light of Christ will become brighter and brighter until the darkness cannot be sustained. (John 1:5)

During a service I attended at New Season Church in Sacramento, California, Pastor Nathan Rodriguez talked about how when Jesus was dying on a cross, He acknowledged in John 12:27, that He was *born* for that moment, "Now my soul is deeply troubled. Should I pray, 'Father save me from this hour'? But this is the very reason I came!" Pastor Nathan made a great point in that rather than looking at our problems as something we are defeated by, we must look at them as something that God has prepared us for since the beginning of time.

You were born for this circumstance;
You were born for this season;
You were born for this moment!

Although it is not biblical that God would do you any harm or evil, I do believe that He permits consequences to your actions so that you can learn, grow, and make better decisions. Hebrews 12:11 says, "No discipline is enjoyable while it is happening—it's painful! But afterward there will be a peaceful harvest of right living for those who are trained in this way." Furthermore, God is full of love,

goodness, grace, and mercy. The ultimate proof of this is Jesus dying on that cross as the Son of God. He was the perfect sacrifice given so that you may see how much God loves you. Because of His love, God turns every unfortunate circumstance, and everything that represents darkness and death, into something beautiful.

Isaiah 61:3 says,

> "*To all who mourn in Israel, he will give a crown of beauty for ashes, a joyous blessing instead of mourning, festive praise instead of despair. In their righteousness, they will be like great oaks that the LORD has planted for his own glory.*"

I hope that this verse gives you as much hope as it gives me. God exchanges your ashes for beauty, mourning for joyous blessing, and despair for festive praise. There is an act of obedience, though, upon the power of this verse, and that is when it says, "In their righteousness... ." When you *choose* righteousness, it means you are making a decision to live according to the word of God, through repentance, so that your heart may be aligned with the will of God, living at one with Christ. It is then that you find beauty, praise, blessing, and, ultimately, freedom!

As we pursue our righteousness in Christ through faith, we experience transformation through a process called sanctification. Sanctification requires a renewing of the mind, replacing fleshly desires with godly ones, and making changes in habits and ways of living. Righteousness does not mean you are designed to be perfect; it means you are called towards repentance through the

grace of our living God. Miracles, on the other hand, do happen instantly. In moments of the need for a miracle, God will work on your behalf. Living righteously is a lifelong journey that you should not be afraid of but excited for. The more you engage in your relationship with Jesus and learn how to live biblically, the more you will grow into a place of righteousness. As the light of the world, He will guide you through it. (John 8:12) Do not be discouraged with how long it takes you to grow in Christ. This process is not a sprint but a marathon. You have your own process to go through with your own path. You have your own trauma you are healing from,

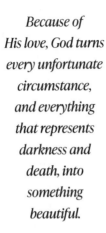

Because of His love, God turns every unfortunate circumstance, and everything that represents darkness and death, into something beautiful.

your own set of people who you are in the process of forgiving, and your own destiny that is yet to be fulfilled in God's perfect timing. Enjoy the process of your spiritual growth and allow the power of Jesus to teach and refine you along the way.

The Prayer

Dear Heavenly Father,

I pray with a thankful heart, that you sent your one and only Son to a cross to show your daughter reading this what true love really is. I thank you for this act of love while freeing your daughter from being a slave to sin and to have

a grace upon her that allows her to be forgiven. Thank you for giving her an ultimate reason to repent from sin, and to live not for her own fleshly desires, but for you and only you. May you open her heart, mind, and soul as the flames of your Holy Spirit are ignited within her spirit, so that her worldly desires burn away and she is left with the desires of your Heavenly Kingdom. I pray that you show her that because of Jesus dying on a cross, she is loved and forgiven for all eternity. I pray that you show her that because of Jesus rising from the tomb, that once she accepts you into her life as her Lord and Savior, she has the Holy Spirit within her—the one who comforts her, who gives her a gift of living in godly righteousness, and who gives her the authority and wisdom to live according to your divine will over her life.

I declare and decree a greater revelation to be placed upon her spirit, Father; that as she learns about who you are, she has a deeper understanding of your love for her. I pray that she is able to accept your grace, repent from the things not of you, and move forward in life, leaving who she *used* to be behind her. I thank you for reminding her that she is not alone in this journey. Bless her, God, for her deepest desire may be to serve you but she might not always know how. Present her with more community, mentorship, and people around her who love her for who she is as a daughter of God.

I pray this prayer in Jesus's Name,
Amen

The Practice

Prayerfully read over these questions and begin to answer them as honestly as you can.

1. Who do I know who has gone through what I've gone through or is going through it now? Who do I trust to talk to about what I've gone through or am going through now so that I can begin a process of healing? In what ways has Jesus experienced what I've gone through or am going through? How and when will I connect with others and with Jesus so that I can begin a process of healing?

2. In what ways has God shown His love for me in the past? In what ways is God showing His love for me now, even in the midst of my challenges? Who can

I connect with if I have doubts about God's love for me? What are some verses in the Bible that talk about God's love for me?

3. Seeking and standing in righteousness is a daily choice and eternal process while on earth. What decisions can I make in my life today that will allow God to see my willingness for change as He helps me renew my mind, heal, and become a more whole person?

CHAPTER THREE

———————————

God Is Spirit

For the Lord is the Spirit, and wherever the
Spirit of the Lord is, there is freedom.

— 2 CORINTHIANS 3:17

The Poem

"Expired"

BY CASEY CASSADY

Expired.

Is what they've called me time and time again.

And just like them I was tired of waking up finding myself
in the same situations, with the same problems,
staring back at the same men.

The same men who all had different names:
insecurity, condemnation, rejection, lust, shame.

They must have wanted nothing more but to define me
as a playing piece to a player's game.

My name might as well have been "the battery sold separately"
because the voids in my soul led me to think

that a woman like myself needed the things of this world
so desperately.

⌒◡

I was expired.

So the more I held on to my past,
the more my morals were non-existent, stripped, gone;

They were non-existent stripped and gone.

Not even a cast could mask the stashed trash
and brokenness within me.

My identity was left out on the counter spoiling.
I was troubled and toiled with trials

rather than living in my God-given royalty.

⌒◡

Having toxic relationships and locked-lipped relations
with men who just wanted to be wanted.

They tied me to their hips, and called all the shots;

as though they deserved to be worshipped
and treated like gods.

Because I sipped on the poisonous perspective
of love and intimacy that I defined in a way –
that deeper and deeper slipped into the voids I portrayed.

Just so I would not be thrown away;
but be defined as "a keeper."

But it wasn't until I found Jesus, that I found
anything sweeter.

And in my mind, I knew it was time to ask God to get on this.

To help me get through these storms so I could start over.
Because, can I be honest?

Christianity at the temperature of "lukewarm"
had never felt colder.

Because at times, I felt so distant from God
– so far apart and in some moments of life,
I'd wake up with such a heavy heart;

that I couldn't even talk to God,
so I would just ask him to hold me.

Until I came to a place where my lips could
speak scriptures of spiritual coping.

I was fighting for air.
My lungs needed to breathe.
I could no longer suffocate in a world that
brainwashed me into a neurological disease.

A world that handed me drink after drink,
with this quenched-type thirst

not knowing anything about how if I'm not careful,
I'm bound by a curse.

Or how I no longer had any self-control

and how everything about myself that
I was supposed to protect

– it stole.

But "we're all just having fun", right?

Despite the fact I would wake up the next day
in a spiritual battle and self-hatred fight.

So as I sat there expired, I was officially drained.
And at that point in my life,
my only desire was to find eternal change.

Because being expired no longer received my agreement;
but this was the title placed upon my flesh
when God spoke to me

"leave it."

⌒

So I've been brought to a place where I choose freedom
rather than captivity. I choose for my arms to be lifted in praise
rather than chained.

I choose a Heavenly Kingdom over world founded plasticity;
and for my heart to be shifted
because of who reigns.

There is so much to press forward to and
so much wisdom to gain.

So I continue on seeking the light shining over my pain.

⌒

Expired.

Is what they've called me time and time again.

But the only things with an expiration date label
were the unstable mindset and lies that I laid on the table;
the day that I chose a new life that God then let me begin.

⌒

I'm no longer who I was before,
because God knew, that through his Spirit –
I'm divinely, righteously, and completely able.

So each day, I'm awakened by the voice of my Father,
the face of my Lord as he whispers,
"My daughter, because of my grace,

we've won this war."

So I've been sent here to ask you:
What is He whispering to you?

What do you need to leave,

or do,

so you can have freedom?

Because just like me,

you are no longer

expired.

The Principle

First Corinthians 3:16 says, "Don't you realize that all of you together are the temple of God and that the Spirit of God lives in you?" If you are a believer in Christ, you have the Holy Spirit within you. It is important that you are aware of why we need to have the Holy Spirit dwelling within us, and how you can live in the authority of Christ while being led by God's Spirit. When Jesus was preparing to die on the cross, He said that He would send His Advocate to us. This "Advocate" He speaks of is the Holy Spirit. Jesus knew that we would need His Spirit once He no longer walked the earth as a man; we cannot truly step into our God-given purpose here while facing the battles of the world alone. And this is why He was resurrected from the grave after His death, so we would be able to have the Spirit of God within us while living in such an imperfect world.

The Holy Spirit is not to be viewed as less than God because the Holy Spirit *is* God. God wants His beloved children to be able to connect with Him in the realms of Heaven, and the Holy Spirit does this for us. As Christians, the Holy Spirit is so important to understand. There are hundreds of books and teachings out there solely on how to understand the Holy Spirit, such as *The God I Never Knew*, by Robert Morris, and *Bruce & Stan's Pocket Guide to Knowing the Holy Spirit: A User-Friendly Approach*, by Bruce Bickel and Stan Jantz; but here are some of the things that

I have personally learned and recognized about the Holy Spirit.

First, the Holy Spirit is a tangible presence of God and our direct link to Him.

The Holy Spirit is God and who we feel when the presence of God is near us. It is who allows us to feel the supernatural peace of God, the joy of God, the warmth of God, and to actually hear the voice of God when He speaks to us. When we are in worship or prayer, the Holy Spirit allows us to recognize that "God is here." How wonderful is it that we are able to feel Him with us, rather than only having to depend on our knowledge of His existence? Have you felt the presence of God?

Second, the Holy Spirit is our Teacher of the things of God.

I love talking about the Holy Spirit as a teacher, because I can honestly tell you through experience that I have learned and gained so much wisdom from the Holy Spirit. There are many ways where the Holy Spirit can be a teacher, but perhaps my favorite is literally asking Him questions and having conversations with Him. I always take the opportunity to talk with and ask questions of the Holy Spirit, whether on the go, in deep prayer, while reading the Bible, or when having a conversation with someone. Through the Holy Spirit, we are able to communicate with God the Father, so I literally ask Him everything—questions about life and people, to show me visions, to give me directions on a spiritual assignment, about a specific Bible Scripture

and how it applies to my personal life, and the list goes on.

These prayers simply start off with saying, "Hi, Holy Spirit! I have a question. Why does...", "Can you tell me...?", "Please explain...", "What does this mean?", and so much more. If I make sure to give Him my time to hear an answer, I get one. God desires to teach us things when we have questions, concerns, or are trying to help and love other people. That's why He gave us the Holy Spirit in the first place—to teach us everything and remind us of everything Jesus has told us. (John 14:26)

The world is broken but that doesn't mean you have to be.

There are other ways we learn from the Holy Spirit as a teacher, like when we pray for and are given wisdom and discernment. And when we allow the Bible to come alive in our lives through careful study and reflection. We also learn from experiences and trials we face. Sometimes life is the best teacher, the school of hard knocks. As I said, there are so many ways to learn wisdom from the Holy Spirit, and we should never take this amazing resource for granted.

Third, the Holy Spirit is our Comforter and Strength.

God placed you in the world because He knows you are strong enough to face it. The world is broken but that doesn't mean you have to be. God knows that you would not be able to properly endure, respond to, or grow from various challenges of life without the Holy Spirit as your Comforter and Strength. He has plans for you that come after seasons of adversity.

Through comfort and strength, the power of the Holy Spirit sustains us through even our darkest moments. The love and sacrifice of God behind Jesus's crucifixion gives us an ultimate reason to put our own sin and old selves to death, while His resurrection gives us the ultimate power of the Holy Spirit to sustain our new, Spirit-led lives. Every season of adversity refines who we are *now* so we can continually evolve into who we truly are in Christ. Our old selves, mindsets, and habits begin to disappear through divine transformation, as we seek His comfort and strength.

Do not dwell on the current storms in your life, but have faith in knowing that if you press forward in faith, there will always be a rainbow and sunlight on the other side.

In John 14:15-17, Jesus promises to have "another Advocate," the Holy Spirit, sent to those who "obey his commandments." We also see in Psalm 119:50, "Your promise revives me; it comforts me in all my troubles." God is faithful to *all* that He has promised us, and I hope that this verse can apply to every area of your life; I believe that this verse specifically can speak volumes to the Holy Spirit being our comforter in all of our troubles.

In those moments where you don't think your heart could be any more broken, where you don't think you could be any more stressed, or where your deepest fears become a reality, God has promised that the Holy Spirit, our Comforter, will bring you the peace, strength, and joy to endure.

Do not dwell on the current storms in your life, but have faith in knowing that if you press forward in faith, there will always be a rainbow and sunlight on the other side.

Fourth, the Holy Spirit is the host of our spiritual gifts and the foundation of miracles.

Without the Holy Spirit, we would not be able to tap into the supernatural power and gifts God designed for us to use while on earth. Romans 12:6–8 says, "In his grace, God has given us different gifts for doing certain things well. So if God has given you the ability to prophesy, speak out with as much faith as God has given you. If your gift is serving others, serve them well. If you are a teacher, teach well. If your gift is to encourage others, be encouraging. If it is giving, give generously. If God has given you leadership ability, take the responsibility seriously. And if you have a gift for showing kindness to others, do it gladly."

There are several other gifts as well that you can read about in the Bible, but the point of mentioning this is to glorify (to make known) the Holy Spirit for dwelling within all believers of Christ. He is the reason as to why we have the ability to use our spiritual gifts to help others, and ultimately, to glorify Father God for the healing and restoration of others' minds, bodies, and/or spirits. If you are not familiar with what your spiritual gifts are, I highly encourage you to look online for a free spiritual gifts test, or ask your pastor about what he or she recommends.

Being aware of and using our spiritual gifts is not something to boast about but something to be thankful for. Using them will often take a leap of faith, but like anything else, the more you put it into practice, the more comfortable you will be for God to use you in your giftings.

I remember the first time I realized I had the gift of knowledge. Three years ago, I was working as a medical

office receptionist. My eyes drifted to a man sitting in a crowded lobby, and I began quietly praying for him. A few moments later, I suddenly felt as though "I just knew" that he had pain in his right arm even though I worked in a completely different department that was irrelevant to arm pain. I asked him if he did have that kind of pain, not quite expecting the response I received. He confirmed this word of knowledge (he was even a patient of an Orthopedic Surgeon), and although I must admit I was a little bit surprised, I said a prayer for his arm and declared the healing power of Jesus over it. I briefly saw him again several weeks later, and he joyfully thanked me (as we gave glory to God) for what had previously happened; the pain had subsided. The overwhelming joy I felt from that experience (and many experiences following) is almost unexplainable—it was the most rewarding, fulfilling, and warm feeling compared to anything else.

If this is something you are not particularly familiar with, be encouraged to tap more into the spiritual gifts that God wants to release from the Holy Spirit within you. The worst that could happen is that someone could feel in the moment that what you are saying does not resonate with them; however, if you are purely being obedient to the voice of God, you will never truly be wrong. For me, that prophetic word, that encouragement, that prayer— it had to be done at that exact moment. The word of God is living. Everything God urges Christians to do on behalf of Jesus in the Bible can still be done today. A few of my favorite Christian leaders, who I believe would be good for you to learn more about regarding the use of spiritual gifts, are Oral Roberts, Bill Johnson, and Todd White.

Fifth, the Holy Spirit is a prayer warrior.

Whether you are speaking in tongues or your own native language, there is power in prayer that is activated and led by the Holy Spirit. I believe that each season of life will call us towards specific prayer and that prayer should be led by the Holy Spirit. There is nothing wrong with asking for prayer requests and praying over things that you didn't have to necessarily "listen to the Holy Spirit" to know because someone else told you themselves. In fact, doing this is a good way to connect with someone and to show that you care about their needs. However, if you are active with reading the word of God and have grown accustomed to hearing the voice of the Holy Spirit because of your relationship with Christ, the Holy Spirit loves to divinely invade your prayers and prompt you to pray for specific things that you may not have prayed for otherwise.

It is important to always use good judgment when praying for other people out loud. It may depend on the sensitivity about the topic, on the environment around you, and if the person is ready to face certain pain in order to heal; but oftentimes, the Holy Spirit does show and tell you specific things to pray in that moment if you are listening. Praying out loud when directed by the Holy Spirit is powerful. It can plant seeds of a new beginning to someone else's life; it claims and practices godly authority that causes the enemy to flee; and it can be used as confirmation and encouragement for someone else's fears and doubts. Praise the Lord for the Holy Spirit being a prayer warrior!

The Holy Spirit is so much more than anything I am able to put into words, but I genuinely wanted to share with you just a glimpse of how the Holy Spirit has changed me on the inside and my life on the outside. Let's again refer to John 14, and this time, specifically, verse 17, which says, "He is the Holy Spirit, who leads into all truth. The world cannot receive him, because it isn't looking for him and doesn't recognize him. But you know him, because he lives with you now and later will be in you." People of the world (non-believers or those who don't have a relationship with Christ) are not able to recognize the Holy Spirit; but once He is within you, He gives you full access to all of the wonderful things He has to offer. He is truly a gift that should not be taken for granted, but should be fully exercised in order to heal others physically, spiritually, and mentally; ultimately, to bring glory to God through wisdom, comfort, strength, spiritual gifts, and prayer.

The Prayer

Dear Heavenly Father,

I pray with thankfulness for every one of your daughters who has the Holy Spirit dwelling within her. I pray over your daughter who is reading this right now and lift her up to your Throne. Through the power of the Holy Spirit, may she live in the authority of Christ, serve and love you wholeheartedly, use the spiritual gifts you've given her, and develop godly character for the glory of God. May she become a true prayer warrior, be comforted and find strength through challenging times, maintain the posture of humility while always being a learner, and be led by the Holy Spirit while living glory to glory as she is taken into her true destiny. May she always embrace the Holy Spirit in new and deeper ways like never before. Allow her to experience encounters with you through the Holy Spirit that meet all her godly desires and personal needs.

I pray this prayer in Jesus's Name,

Amen.

The Practice

Prayerfully read over these questions and answer them as honestly as you can.

1. What are some ways I can include the Holy Spirit in my daily life?

2. The Holy Spirit is a teacher. What in my life, within myself, or about others do I have questions about that could help me find forgiveness, healing, wisdom, and so on? (Ask the Holy Spirit to reveal these answers to you and write them below.)

3. The Holy Spirit is a Comforter and Peacemaker. In what areas do I need the Holy Spirit to comfort me and give me peace right now? (Invite the Holy Spirit into these areas and feel His comforting and peaceful power over you.)

4. The Holy Spirit is the power of our spiritual gifts (once we receive salvation). What are my spiritual gifts? How can I apply these more to my life moving forward in order to be used by God to help others?

5. How can the voice and direction of the Holy Spirit help me in my decision making, prayer life, and to help others through the spiritual gifts He has given me? What questions will I ask Him for this?

God Is Creator

Put on your new nature, and be renewed as
you learn to know your Creator and become
like him.

— COLOSSIANS 3:10

The Poem

"Highness"

BY CASEY CASSADY

Born into a family of dysfunction at its finest-
At 7 pounds, 6 ounces and a little bit of likeness;

She left the home of her mama's womb,
With a destiny of being crowned God's Highness.

And within her, there's a light,
that is the brightest shade of whiteness;

But this did not always keep her from the growing pains
that began the very moment of her birth,
since her mere existence is a sowing threat
to the ruler of the Earth.

So as the experiences of childhood-turned-womanhood
somehow appeared sooner than she thought,
she watched as her fantasies of a perfect life sat on a shelf to rot.

She found herself in battles that she never
dreamed she'd have to fight.

But through all the snakes with rattles,
she was healed from every bite.

And through all the trauma, and heartbreaks,
and the rejection she faced;
her vision began to vanish of a white dress stitched with lace.

And through the pain of near-death experiences,
and the ones she doesn't know about
because her God made some interferences;
through the thoughts of what she wanted her life to become;
compared to the non-fiction story;
she can easily say that once she defined who needed the glory;
she redefined what in her life became priority.

And in Heaven where she's from, there is a seat for her return
placed carefully for one day when it's her turn.

But that day is not today, it's only in God's timing
because even through her darkest days,
she prays, "Papa, please remind me."

"Remind me of your love, remind me of the vision.

That you had of me, before you made the decision,
to create with so much precision –
a human being like me;

To have the capacity and drive in this generation
to be able to thrive in a world that lacks godly demonstration!"

She's perfectly imperfect;
she's beautifully flawed.

But she learns lessons each time; I promise she tries.

Through the Grace and wisdom of only our God.

And because she is called, to not fall but to rise.

With each word from her lips and her tongue,
she breaks off the lies.

She has regrets from so much,
from the times of her falling.

But with every heavenly touch, she captivates her thoughts
and remembers her calling.

And with a calling, comes purpose, and a worth,
she's been given.

So that not because of her past life of sinning,
but because of her claiming her victories;
and the revelations of God's mysteries;

She is faithful to find the best,
and many reasons for living.

Cƒƒ~

The Principle

While God is so much more than just our Creator, this is where it begins. You have been created perfectly in His image, wonderfully and fearfully made. Imagine yourself as a baby in your mother's womb. You are pure and innocent, and there is already an entire plan of God's deepest desires for the life you are about to soon live. You have an entire life ahead of you to make decisions, learn from the people around you, and seek your true identity. But being that baby also means you are dependent upon others, and you need proper care to be healthy and learn how to maintain your purity and innocence.

Unfortunately, because of the brokenness and evil in the world today, truly seeking and becoming who we have been created to be is a lifelong journey and cannot truly be realized until we are in Heaven. From the day we are born, we are forced to face experiences that can potentially traumatize us and cause us to believe lies about ourselves, others, and God. When not replaced with the truth that is in God's Word, these lies influence the way we respond to trauma and injustice, which may cause us to undesirably take our bondage with us into adulthood and even into the last days of our lives. But in the meantime, each one of us is created and born with a purpose for our existence on earth. This is why we must face a battle every day to become who we once were before we were exposed to the world, as well as who we will be one day in Heaven.

When we see God as Creator, we are given a chance to see His vision for us and the world around us. Something cannot just be created without first having a vision for it. Just like how we have the capability to create things we are passionate about when we first have a vision of what those things are, God, too, had a first vision of you: what you would look like, who you would be, and the amazing things you would be able to do (in Him) throughout your lifetime on earth. As your Creator, once God had this vision, He knew there was absolutely no other choice but to create something so beautiful and filled with purpose. Furthermore, in the microscopic space between the moment of His vision and the moment of His creation, an eternal promise is placed: through the darkness and heartbreak of this world, both His creation and vision will come together in Kingdom-alignment so that your true purpose may be fulfilled.

Because God is the creator of both you and of the world, nothing is impossible.

Who have you been created to be? Are you already that person? If not, ask the Holy Spirit why it is challenging for you to be the person you are meant to be. This may be a time where you need to reevaluate your influences and become the influencer. Make the decision to make good decisions. Believe that God has so much more in store for you. Because God is the creator of both you and of the world, nothing is impossible. When God created you, He knew that you would come with needs, desires, and dreams, because He creates those too. He also creates the things to meet your needs, fulfill your desires, and turn your dreams into realities. When I had

dreams and visions as a child of what my life could be like one day, I perceived them as only fantasies that would never come true. Because of that, I had no purpose-filled vision to work toward, which meant I had no direction to take. I was goal-less, indecisive, uncommitted, and confused. I have learned that vision is so significant because it helps define a part of who we are and what we are created to do while on earth.

When you see God as Creator, it should give you peace. Because of His vision for your life, everything is already taken care of. All you have to do is follow His lead—through the pain and the joy. He would never create such a beautiful soul for no reason at all. When you accept and believe God is your Creator and allow the Holy Spirit to guide you, you begin to realize God is guiding you into the glory He created you to be in. He has been with you through all of your challenges, yet He still believes in the true you and what you are going to become. That is the true glory: knowing God sees all of your imperfections and still loves you. He is still committed more than ever to guide you through your dreams and desires into your destiny.

The Prayer

Heavenly Father,

I pray over the beautiful soul reading this book. I pray that as you begin to reveal her identity to her more and more each day, she sees you as the Creator that you are. I pray that as she goes to sleep each night and as she wakes up every morning, she is reminded that you have a vision and a plan for her entire life since before she was born. I pray that you take hold of her heart, and that all desires of the world are released and replaced with only the desires of you, Heavenly Father. I pray that as her mind, heart, and soul are being renewed, purified, and aligned to your perfect will, her own vision for her life becomes clearer.

I declare and decree that as she sees you as the One who created her and the world, she begins to listen to you teach her about who she is and what she is capable of while she is living on earth. I pray that anything Satan has done to hinder her from being who she has been created to be is broken off of her life, in Jesus's Name.

I declare and decree that any generational curses that are hindering her from her calling are broken off in Jesus's Name. I ask, Papa, that you show her how to replace every lie she believes with the Truth of the Word. That she can look in the mirror and recite Scripture that describes your love for her, and how only *you* define her as a daughter and

as a woman of God. I thank you, Father, for creating such a beautiful, worthy, and powerful woman. I prophesy that as her relationship with you becomes deeper, she lives in her full authority and is taken into a destiny that allows her to glorify you as she becomes an influencer of this world.

I pray this prayer, in Jesus's Name,

Amen

The Practice

Prayerfully read over these questions and begin to answer them as honestly as you can.

1. What do I believe is God's plan and purpose over my life that He has had for me since before I was even born? What things am I naturally talented at that I enjoy doing? How could I begin doing these things to help other people? What could I do now that would help provide me with opportunities to do these things as an enjoyable and fulfilling career or ministry?

2. My "true identity" in Christ is being who God has
 created me to be. What about myself do I let others
 define or change? Why do I struggle with not being
 true to who I am in Christ, and how can I overcome
 those obstacles?

3. How have I been, or how can I be, intentional about
 seeking who God has created me to be? How can I
 begin, or continue, to heal from my past trauma so
 that I can fully be who God has created me to be?

God Is Savior

"I, yes I, am the LORD, and there is no other Savior. First I predicted your rescue, then I saved you and proclaimed it to the world. No foreign god has ever done this. You are witnesses that I am the only God," says the LORD.

— ISAIAH 43:11-12

The Poem

"The Finest Freedom"

BY CASEY CASSADY

I was enslaved to sin. Gambling to win.
I could NEVER be or do enough.
A self-righteous life is rough.

Tired of this fake, caked-on, dressed-up stuff
searching for love in a world full of lust
a world that is the very definition of
what it means to be crushed.

⁓

Because—I have learned in the hardest of ways
that you cannot find love,
if you do not know what it is, or where it is found.

Ungodly cycles will keep you bound and chained to the ground
while you hold the weight of what society claims it to be.

Until the world begins to blind you and bind you
with a darkness that becomes a normality;
that even if you wanted to,
is one of the hardest places in life,
to be able to leave.

⁓

And when I realized this,
I made the decision to *finally* listen.

Tears of pain in my eyes, yet for some reason under the Son,
they righteously glistened.

And then I heard a voice so loud that carried
the most gracious conviction.

So much so, that not a soul in this world could have missed it.

⁓

And the Lord said, "Daughter,
you're on the wrong path

but my grace is sufficient, so you still have a chance.
Let me love you in ways you have never been loved.

It's called 'divine romance.'

Within your heart there is an opening to choose me in return
so I'm here to take a stance.

Beloved, come elope with me.
I want a father-daughter dance."

⁓

So here I am—a bride, establishing stability.
And within me is God's Spirit—who gives me His ability.

This transformation means that every day I kill my flesh
to be able to discover –

A woman of purpose and vision;
I can now see fully in color—both my future
and past prison.

⁓

And even though God knew that my decisions
would not always be the best.
He *still* chose to send His Son to a cross to face His death.

So that on day three—He could put His breath
into the middle of our chests.

Lord, I praise You from the entire longitude
of North to South
and latitude of East to the West

My heart is so immersed with gratitude
that it might just burst–cardiac arrest.

⌒

Because even at my worst, God reminds me of my worth.
We must not forget that in us His identity is woven.

We must not forget that we were chosen–first–Corinthian
speaks so greatly of what love is.

And by knowing that God is love, and that He loves me
just proves that I am His.

⌒

When the world attempts to tear me down
the Lord always lifts me up
and crowns me as a Queen.

Because even in my darkest days,
He sees me as pristine.

⌒

Through a lens of pure love that forever leaves me in "awe"
because His vision is so perfectly wired.

That it caused my obedience to religion and law
to change to a pure-hearted desire.

And I don't know about you, but me?
I never again want to see Jesus's face to Him losing me.

So onto my face, He's gluing me
every day, He's wooing me

Because when I show my groom that He is worth the wait.
He never stops pursuing me.

To a place where I'm not just a sip or a taste.
But I am fully embraced.

You see, He's not just a god, He is Majesty.
Yet, before He rose from a tomb, He still chose
to shed His blood on a tree, so tragically.

This is not intended to be perceived so casually
because regardless of who has rejected you
and attempted to leave magically...

We hold the finest freedom.

In the highest Kingdom.

Because God loves passionately.

The Principle

> *For this is how God loved the world: He gave his*
> *one and only Son, so that everyone who believes*
> *in him will not perish but have eternal life.*

> — JOHN 3:16

Receiving salvation means accepting Jesus as our Savior through believing He was sent by God the Father to be crucified and resurrected on the cross so that we may be adopted as His own and given eternal life in Heaven. This is a decision that is made in faith, and it recognizes that there is no one more worthy and more loving than God the Son (Jesus Christ) to be our Savior. It is also trustworthy because it is based on the truth of the Scriptures, witness testimonies of many people, and your own spirit testifying with God's Spirit.

But when I think of God as Savior, I think of more than just the gift of salvation—I think of His perfect love. I think of the ultimate sacrifice He made. I think of how He did everything He could do up until His death to experience *everything* we experience in every season of our lives so He could fully relate to us. I think of how He wants nothing more than to have an intimate relationship with us; how

His grace has given us a chance to conquer our title of "sinner" by choosing to claim our identity in Him. Jesus's identity became unrecognizable just moments before His death so that we could be given a chance to recognize ours for the rest of our lives. He gave up His health, identity, and life in exchange for ours.

When we see God as Savior, we are truly able to see how much we are loved because He literally died for us. Seeing God as Savior gives us an identity because it gives us the opportunity to choose Him as our Father. What more could He have done to prove His love? What more could He have done to tell us that He only wants the very best for us? The answer is this: *nothing.* God doesn't require us to physically experience what He went through for us, but we are commanded to die to our flesh so that we may live for Him. And by living for Him, we can be confident that He fulfills all of the desires of our hearts. Why would we not want to return the love we have for Him to meet His desires too? Just in case you are wondering what His desires are, allow me to mention a few:

Jesus's identity became unrecognizable just moments before His death so that we could be given a chance to recognize ours for the rest of our lives.

God desires for *all* of His children to choose Him because of what He has done on the cross so that none perish but have eternal life in Heaven with Him.

He desires that just as He (Jesus, God the Son) obeyed God the Father by fulfilling His assignment on earth and dying on the cross to demonstrate the *greatest love of all time,* that we would obey Him to show our love for Him.

He desires that through our obedience, we are promised

that He shall see us as righteous so that as we are at one with Him, being molded into a reflection of Him. In return, atmospheres are shifted, lives are transformed (including our own), and souls are saved, thus growing the kingdom of God.

God desires that we live in abundance, according to His plan and will for our lives. He desires that we are used as vessels so others may see His tangible love through miracles, signs, wonders, and godly encounters.

The ultimate goal of a righteous lifestyle is helping others meet Jesus Christ. But when we choose to submit our lives to God, it is not God's intention for the pre-born-again believers to be the only group of people who benefit. God does not only want to save the non-believers just to become believers; He has His disciples and other followers in mind as well. If He had only died for the non-believers to be saved, then the majority of our "saved" believers would still be living deep in sin and darkness. Jesus conquered the grave so that we, too, can conquer sin. The concept of "conquering sin" should not be confused with justifying sin. As believers, we are not perfect, but it is not biblically sound to justify our sinful actions by taking the grace of God for granted by using it as an excuse to continue sinning. (Romans 6:1, 2) Rather, by submitting to the renewal of our minds, we allow the grace of God to transform our heart's desires, so that both believers and non-believers, who will hopefully one day become believers, will no longer desire the things of the world. (Romans 12:2) When we begin experiencing this, we are being refined for righteousness.

A lifestyle that is aligned with God's Word is a process for everyone, no matter where we are in life, because it is not achieved first by behavior modification but by a heart transformation that only God has the power to give us. God's grace, through both light-filled and dark seasons of life, touches us where we are and brings us to right living. When He does, our hearts may then glorify and worship our Heavenly Father for His love and for all that He has done for us.

Because of the grace of God, you don't have to be perfect. Remember that the journey ahead is a process and God will help you through.

I can tell you I have experienced this firsthand. When my heart desired the things of the world, my consistent behavior of partying, people-pleasing, promiscuity, attention-seeking, and looking for love in all of the wrong places was not getting me anywhere. It wasn't until God revealed to me that His plans and purpose for my life are much greater than I could ever experience without Him, that I began to pray for the desires of my heart to change. It was then when God began to rock my world in a heart-transformation process that I had never allowed Him to take me through before.

And as I was intentional about building my relationship with Christ by finding a Christian community, finding a home church, and being in the Word and in prayer, the desires I once had literally started to disappear. I began to recognize more of my identity in Christ, and suddenly, because of the grace of God, the way I used to live was not nearly as appealing to me as being in the presence of God. My heart was continuously being repositioned

toward things of the Kingdom; toward who I am created to be, rather than who society wanted me to be; toward how God could use me to help other people and bring them to His glory. Breaking curfew may have been considered "freedom" to me thirteen years ago, but there is no sweeter freedom than finding identity in Christ and experiencing the plans and purpose God has designed me to experience.

You may be asking, "Where do I even start?" First and foremost, start with a prayer. God does not often intervene with our lifestyle and decisions if we aren't desiring change, and you can do that by praying. Let God know you desire change, and that you come into agreement with His perfect will over your life. Ask Him to shift the desires of your heart, and then be intentional about building your relationship with Him while making better decisions for yourself and for your future. I am not accusing you of "living in sin" or "being a bad person," but I think we can agree that when we let go of certain habits and distractions, we make room for a very-much-needed relationship with Christ.

Next, I encourage you to be intentional about finding and being around Christian people who truly do their best to live according to the word of God. I will expand on this specifically in the next chapter, but I believe that finding a community of believers, if you don't have one already, would be a good next step for you. If you are not ready to make certain changes or fear that you might fail, do not be discouraged. Because of the grace of God, you don't have to be perfect. Remember that the journey ahead is a process and God will help you through.

The Prayer

Dear Heavenly Father,

Thank you for being our Savior. Thank you for dying on the cross so that we may have a choice to believe in you; so that we may have a relationship with you; so that the Holy Spirit dwells within us while renewing our minds and transforming our hearts; so that we, as your daughters, are led glory to glory and learn through the Holy Spirit how to conquer sin just as you conquered the grave by your resurrection power. I pray over every woman reading this book —that you reveal to her more of what being her Savior means to her in this current season of her life.

I pray that you deepen her desire to grow with you. I pray that you teach her more of who she is in Christ, by taking her deeper into her God-given authority, her gifting, her victory, her calling, and her destiny. I pray that you continually remind her of how far your love and goodness has brought her; that because of *you*, she is no longer who she used to be. I thank you for placing Christian people who are good influences into her life. I rebuke anything that may hinder her righteous walk with you and that she will, in fact, be able to flee from temptation and conquer her sinful nature through the continuous journey of mind renewals and heart transformations.

I pray that the more she sees you as her Savior, the more she is saved from bondage; that she finds healing and freedom in areas she never has before. Father, thank you for loving her so much that you chose to die for her; a death that led you to become unrecognizable so that through faith, she would be given an identity in Christ forever.

I give you all of the praise, all of the glory, and all of the honor.

In Jesus's Name,

Amen

The Practice

Prayerfully read over these questions and begin to answer them as honestly as you can.

1. How does God being a Savior apply to my life? What things do I need to be saved from so that I may be able to live according to the plans and purpose that God has over my life?

2. What is God showing me about His character and about myself that demonstrates a reason and/or an outcome of Jesus dying on a cross for me?

3. What is the significance of God giving grace to all of
 those who believe in Him and in what He has done on
 the cross? How can I better receive God's grace over me
 and over my life? In what areas do I need God's grace
 the most?

4. In what ways can I extend the grace of God in my
 personal life to others who need His grace as well?

God Is King

Sing praises to God, sing praises; sing praises to our King, sing praises! For God is the King over all the earth. Praise him with a psalm. God reigns above the nations, sitting on his holy throne.

— PSALM 47:6-8

The Poem

"Through His Reign"

BY CASEY CASSADY

I'm in a "rising up" season, I need to endure this.
The Lord has His reasons.
He's curing my purpose.

Satan has tried hard, but he can't hide me;
at first his lies come off so shiny,
but I'll try him for treason.

Because the Light has come down
so it's no longer pre-Son.

It's no longer pre-won.

I'm running a race that I've already placed,
so it's no longer pre-run.

I claim with the authority that's been locked,
what's already been given.

My own eyes might not walk, but my Faith does,
so I'm already winning.

And it's okay if at times you feel like you gotta stop —
and take a breath.

I know it's a lot, to witness a death.
When an innocent man didn't just take a bullet for you
but by no mistake,
took a cruel hit of everything evil stands for, for you.

He did this so you can find freedom in the midst of His Kingdom.

You must learn how to fly some day;
as your flesh dies, don't be so wing-dumb.

Because I've learned the hard way
that it may not be wise to fight for what's been
fighting against me all of this time—

Forgetting God's got it.
I don't have to figure out crime
Even when Satan thinks that he plotted it.
No debt on my watch

Only Shalom with my Father—
His death already bought it.

I'm on the right path, I've already asked.

The Lord passed me some Grace and guess what,
I caught it.

Because my Father is the final decider
He's my main rider

The more time we spend together,
like budgets, we become tighter.

Through His Mercy, the weight has lifted its judgment
and I've become lighter.

The intimacy we've gained is so off the chain
and His glory pours through His Reign.

He is my ultimate fighter.
an Advocate who says, "She's mine, don't try her."
He says, "I've heard and collected all of the cries,
so now her eyes are a little bit dryer.

I've heard all of her 'Why's?'
and I've seen her anger that she feels
from the deceit of her enemy's lies.

But now, it's her time to rise.
This whole life-changing thing, is just a disguise.

To align her with the timing of My Heavenly skies
she will be able to praise Me through all of the pain
because now that she's in the right lane

My Glory will pour through my Reign."

⌒

"Hear Me when I say:
get ready to be released, this is your day.

Your true purpose will shoot forth and not cease –
because you have been gifted an anointing
that is the water and grease used to ignite a fire so hot.

You're going full force, with my Word and my peace,
so the least you can say is 'My Lord, of course, yes, why not?'

⌒

"Vertical transparency throughout your mission,
will bless you with clarity in every decision.

And no stars will be horizontally shooting in the moments of
darkness because even in those moments
you won't need to be wishin'.

You shall not want, because you'll have My provision.
It is installed within you and only for you;
"So therefore, it's hidden.
I once cut you open, do you see the incision?

Yeah that was the time that
I switched your blood with mine.

The day that my love wooed
you to be Christian.

And you never looked at life the same,
when you gave Me your shame,

You gave me your brain.
Your body is my temple,
so you gave me your frame.
Your eyes opened to a whole new game.

And you knew at that moment,
that my Glory would pour through my Reign."

The Principle

Discovering the heart of God as Father is completely life-changing; and so is recognizing His power as King to reign over every part of our lives. Once we truly desire to submit our lives to Him, to serve Him in the way He has designed us to, then we are able to fully experience God as King and the power He holds as He reigns from His throne in our lives. The more you meditate on what His unconditional love has done for you, the more you will be able to love and serve Him in ways you never thought possible.

James 4:8 says, "Come close to God, and God will come close to you." This is not only Scripture; it is a promise. God promises that once you show Him your willingness to have a relationship with Him because of what He has already done for you at the cross, He will do the same (and more) in return. As you grow with Him, you will be able to encounter Him in ways you never have before. Here are some of the things you will be able to experience either more of, or for the first time, when you draw near to God:

- You will begin to recognize and communicate with the voice of the Holy Spirit speaking to you, which will then also lead you to faith-filled action by the Spirit of God.

- You will often be able to feel His presence more tangibly upon you.

- You will begin transforming more and more into who you were created to be.

- Your character will be defined.

- You will use your spiritual giftings to make a difference.

- You will be able to make better decisions.

- You will experience depth in relationships, your career, and Kingdom-building opportunities that God has in store for you.

- You will also begin to have more faith in the power and heart of God.

- You will more often see God do things for you that enable you to trust Him on a deeper level. He will show you in endless ways that He has never failed you and never will.

If you are wondering how you can experience our Heavenly Father in these ways, I have some recommendations from personal experience. Being able to experience the heart and reign of our Father includes engaging in some powerful key elements that are vital to your spiritual growth. These elements are very important when building a solid foundation for your relationship with Him.

Read the Bible. If the Bible is hard for you to understand, I encourage you to invest in a study type of Bible. Furthermore, I have personally learned so much of what I believe to be true about the content of the Bible

through the knowledge and wisdom of the Holy Spirit. I ask the Holy Spirit questions all the time, and have learned that when I am willing to stop and listen for His voice, He never fails to respond. Do not be discouraged when you find yourself not always enjoying the Bible. Try not to perceive it as a chore, but rather as a vital tool to help you grow closer to God. Keep in mind that the more you make time to be in the Word, the more you will be able to recognize God moving in your life and within you. This will leave you desiring more of Him and His Word.

Pray to Him. Your communication with the Lord is never a waste of time. He wants to spend time with you. He wants to hear your heart. He wants to answer your prayers. He wants to bless you. He wants to trade your ashes for beauty. He wants to heal you, restore you, and transform you. Talk to Him. He listens and responds. Prayer is not a list of requests but a conversation. Be intentional with listening for what He wants to tell you in response.

Worship and praise Him. In addition to having conversations with God, I encourage you to spend time purely worshipping Him. I agree with the spiritual concept that worship is not just in music or in prayer form but a lifestyle of consistently striving to become more of a reflection of Christ. In fact, Psalm 128:4 (AMP) says, "Behold, for so shall the man be blessed and divinely favored who fears the LORD [and worships Him with obedience]" (obedience, that is founded by the love of Christ, being the foundation of the lifestyle).

Worshipping God by praising Him, expressing your love, gratitude, and thankfulness, submitting your heart to

Him, and inviting His presence into your atmosphere, is absolutely necessary to your spiritual life. Peace, healing, and breakthrough are found in the presence of God through worship. Whether you are living the best days of your life, or experiencing a painful season, worship is crucial. Worship in prayer is also a declaration over your life. By thanking God for His love, goodness, and grace over your life, you are coming into agreement that God is a good and loving God, and He will always take care of you through every season, despite what challenges you may be facing.

Peace, healing, and breakthrough are found in the presence of God through worship.

Prayer and worship also make room for the presence of God because your heart is choosing to draw near to God so that He can draw near to you. (James 4:8) Being intentional about drawing near to Him (so that He will draw near to you) is how His presence becomes alive.

Engage with a community of fellow believers who are both peers and mentors. I encourage you to find at least one person, if not a solid group of people, who God can use to help you. These people do not have to be perfect (because they won't be), but should be living a life of love, morals, leadership, wisdom, integrity, and most impor-tantly, people who are familiar with the word of God and have a relationship with Christ. It is important that as Christians, we are around a group of believers who are strong enough in the Lord to sharpen us as iron, pray for us and with us, help us and encourage us to rise when we have fallen, hold us accountable when we make, or almost

make, poor decisions, and mentor us so that we may continue to grow in our walk with the Lord.

A good way to find people like this, other than keeping Christian friendships and mentorships in prayer, is by going where they are. Try attending a church or church group that is suitable for your age, such as a women's Bible study, a young adult group, or if offered, an interest group held at a church, like for entrepreneurs, if that interests you. Most churches have websites that include a list of Bible studies and groups they offer, as well as the location, day of the week, and time.

... when God gets a hold of us, we define the world.

I didn't realize how crucial having a Christian community was for my own lifestyle and relationship with Christ until the grace of God helped me find one. I also did not realize how ignorant I was to the character and beauty of God until I was intentional about being within an environment of people who knew God in personal ways that I never knew existed. I am certainly not advising you to unfriend all your non-Christian friends merely because of a difference in beliefs. We are called to love all. I have several non-Christian friends who I have learned much from and who I love dearly (even though I now must stay true to my convictions and wisely choose what I participate in). But if growing in Christ is important to you, you must manage relationships and friendships wisely, while making sure you are being influenced by people who can help you grow. It may take a little bit of faith, but once you begin to pray, befriend other believers, and build your rela-

tionship with Christ, God will continue to guide you along the way.

God has moved on my behalf for as long as I can remember, but it wasn't until I had these things in my life that I truly began to meet and grow with Him. I remember several times lying face down on my living room floor with my Bible open and tears streaming down my face onto the pages of my Bible. I had just started reading my Bible, exploring a prayer life, and engaging with a Christian community. To feel God's presence and hear His voice for what may have been the first time in my life—even after believing in the existence of God for over twenty-five years—was (and still is) an incredible experience. I had no idea that I could feel so close to someone; especially someone who I couldn't see with my human eyes. But because I could feel Him in my heart in the midst of my circumstances, the love I felt for Him began to grow. It is the most real feeling I have ever felt.

Deciding to allow God to reign in my life by choosing to submit to Him as my King no matter what that looks like for my life is a decision I have never regretted. I am so grateful that God was and is able to continually transform my mindset and the desires of my heart to align with His heavenly will over my life. I spent a decade making poor decisions by choosing what I thought I wanted my life to be like. When we choose what we think we want our life to look like, while still being rooted with worldly desire, the world will always define who we are. But when God gets a hold of us, we define the world.

The Prayer

Dear Heavenly Father,

King of Kings and Lord of Lords, thank you for always being our King. I pray over every person reading this right now, and ask that you reign over her life in every way needed. I declare and decree a Kingdom-alignment within her life, and that whatever changes she needs to make in this season to be closer to you is addressed right now, in Jesus's Name.

Thank you for drawing near to her, when she shows her faith and gratitude for what you have done on a cross and draws near to you. Thank you for wanting to fight her battles and for equipping her with the tools and the people she needs so that she can experience growth in her walk with you, as well as encounters with you directly.

I declare and decree that she begins to see you as King, the One who reigns over everything. Your power and heart are both recognizable because of who you are as our God and as our King. Father, show her who you are as King and take action in areas where she feels defeated. Allow her to die more to her flesh so that she may live for you and so that she may recognize you as the King who is head of the Kingdom that she has been created to be a part of.

Father God, as I praise you, honor you, and glorify you,
I pray this prayer in Jesus's Mighty Name,
 Amen

The Practice

Prayerfully read over these questions and begin to answer
them as honestly as you can.

1. What challenges am I facing that God is able to reign
 over (to have full control over and bring me into
 victory) as my King?

2. How can I better submit these challenges to God? What
 can I pray, or who can I pray for, so that I can trust God
 more fully within my circumstances (such as wisdom,
 direction, faith, understanding, peace, deliverance
 from anxiety/depression, His love, and so forth)?

3. In what ways can I be intentional about experiencing
 both the heart and the reign of God? (For example,
 making time to be in prayer, reading the Bible,
 connecting with a Christian community, finding a
 home church, and so on.) Which one or two things
 would I be able to focus on doing today or at some
 point this week?

4. If I become intentional with doing these things (listed above) so that God can reign in my life as King, where does my walk with Christ have the potential to take me in my life one year from now?

Five years from now?

Ten years from now?

What would I like to have happen?

God Is Healer

"I will give you back your health and heal your wounds," says the LORD.

— JEREMIAH 30:17

The Poem

"Wounded Warrior"

BY CASEY CASSADY

We all have a story
so that we can give God the glory;
of a testimony of an Overcomer
and hers just happened to be what she
remembered in her brain;
while disregarding the moments that were never
quite fully uncovered.
From different moments of different pain.

She's skinned her knees and has broken bones.
And she doesn't mind sharing surface things like these
but there is so much depth to her that not many know.

Because she doesn't often talk about how
she feels as though she is to blame
too wounded with fear that
she would be shamed

Rejected. Defamed.
Subjected.

Harmed.
Rather than protected.

It's too much to think about.
It makes each day hectic.
Because those scratches and casts
go away with due time.

But the pain deep down, lasts and resides,
of not knowing what happened
within her once-innocent mind;

Because the decisions she made
were not often wise.

And the glimmer of light she once had
begun to leave her deep, darkening eyes.

The people around her loved her, but they never asked twice–
"Why are you becoming this person; why now?"

Because if she had even been given a chance
to answer that question,

She wouldn't know how.

One small lie in her thoughts always led to another–
until a lifestyle of confusion and secrets hurt a sister or brother.

There had to be a solution, there had to be a way out.
But rather than facing her battles,
she was good at being a runner.

And she knew every route.

⌣⌒○

So she ran far, and she ran fast, until she thought
the pain was left in the past

But if only she knew how much all God wanted to do,
was restore every piece of her heart,

He wanted to hold and let His love pour
deep into her soul, deep down to her core;

Until the only person she cried for

was Christ–

her King and her Lord.

⌣⌒○

And one day, she was finally ready;
her face placed upon the Bible, that after ages
she had finally opened.

With tears falling down upon the words of those pages;
because that moment with Abba was golden.
As He touched her heart in ways, no one else ever has—
she prayed, and she told Him,

"Here I am Lord, hold me, and mold me,
into a woman who fears you,

a woman who hears you.

A woman who follows your lead,
while together we bleed;

My mind has deceitful seeds planted within it,
and I just need them to leave.

You see, I don't care what you take out of,
or place into my life that is new,
because right now in this moment,
in the midst of my ungodly sorrow,

all I need is to be a Spirit-led wife—and only to you.

Can I wake up with your joy for the first time
in a long time tomorrow?

Because I have nothing else left,
other than time that is borrowed.

Her wounds then began a process of healing
that she never knew to be possible.
She realized that all she needed in twenty-six years
was a heaven-sent hospital.

That goes by the name Jesus,
as He drew near to meet her at her most broken
and picked up those pieces,
while whispering mind-shifting words that were spoken.

And even though ahead of her is still quite a journey
she was more than grateful to be in a place
where for the first time she was able to say

"God can cure me."

Because He heals even the most broken of Queens.
Not because she's perfect, but rather far from it;
but because by perfection, she is seen,

and she is loved.

And she is cleansed by the reddest,
most sacred and purest of bloods.

So over her, it pours.

So that she can then become the mightiest of warriors.

So beloved, have peace and patience for now.

Because I have this deep feeling that God
is meeting all of your expectations

Despite your "why's" and your "how's"

So as your tongue confesses your faith,
at His feet may you bow.

Because you are His daughter,

Daughter; and your Father is proud.

The Principle

Are you spiritually broken? Do you feel physically, mentally, or emotionally ill? Have you been struggling with finding healing or even peace during your current health-related circumstances? Is your heart broken? I am certainly not against needed medications that assist in keeping you physically healthy and emotionally balanced, when and if needed; however, depending on your reason and choice of drug, some medications and self-coping mechanisms will only mask the pain for so long. And regardless of needing medication for specific health reasons, we should never forget that God is a Healer who has the power and desire to heal every part of your being. Whether in prayer with others or in private, ask God to heal to you. From beginning to end, there are hundreds, if not thousands, of testimonies in the Bible of Jesus healing others, and He promises to do the same for you. Have peace while believing that our Heavenly Father sees your pain, hears your prayers, and has a plan for your healing.

Just like how mental stress can cause headaches, oftentimes physical illness is related to our mental status, and our mental status correlates to our spiritual life. Therefore, there is a deep connection between physical health and spiritual health. God desires for your spiritual life to first and foremost be aligned with Him so you can also receive the physical and emotional healing you need. That can mean that maybe you need to repent from an

area of sinful decisions, or perhaps you need to forgive someone. Maybe God is asking you to "open your eyes" or "get up and walk," just as He has asked others to do in the gospel moments before they realized they had been miraculously healed. (See Matthew 9, Mark 8 and 10, and John 5 and 9.)

Let's visit one of my favorite stories in the Bible: when Jesus rose Lazarus from the dead. If you read the story in John 11, you will see that Jesus instructed Mary and Martha to roll the stone aside that was covering the entrance of the tomb that Lazarus's body was in. Because Mary and Martha believed in the power of Jesus, they were able to obey His instruction. Even through heavy tears, and possible feelings of doubt, anger, and blame, they rolled the stone aside (vv. 32–41). If Mary and Martha had not made the decision to roll the stone aside, Jesus's miracle may have never manifested. But because they obeyed Him, Lazarus was risen from the dead by the prayer and power of Jesus Christ. This same Scripture is also a good example of how even after a miracle, there may be instruction with how to handle the blessing that God has given. After Lazarus rose from the dead, Mary and Martha were then instructed by Jesus to "unwrap him and let him go" (v. 44). Do not forget that God will also direct you with how to properly care for the miracles you receive. You do not want to be foolish with your blessings to only again end up in the same circumstances you were in before. Obedience to godly instruction activates miracles on your behalf.

Relatively, the story of Lazarus reminds me that in a metaphorical sense, we must sometimes accept the fact

that things in our life must die before God will choose to completely bring them back to life. It is important that through prayer, you are able to discern what God is doing in the midst of your circumstances, and that you clearly hear His voice on whatever "dies." Is He removing you from that workplace, relationship, environment, or opportunity because it is toxic or simply not a part of where God wants to take you? If so, you must accept the situation, although it may be painful, and move onto better things. However, if you genuinely discern that Satan is attacking you and attempting to interfere with something that is a part of God's perfect will for your life, there is hope that God will choose to completely restore whatever has "died." Remember to use the authority you have been given in Christ to rebuke your loss. Know that your faith is being tested and that God *never* breaks His promises. Lazarus had to be completely dead, wrapped in linens, placed inside of a tomb, and covered with a stone before God felt that it was the right timing to bring him back to life.

Death is not of God. We can see this most significantly by Jesus *rising* on the cross; and among other examples, we also see this when Scripture mentions in this story that Jesus felt angry (v. 33). I interpret this as Jesus seeing how much pain this family was experiencing and, therefore, He was angry at Satan for the death of Lazarus. Furthermore, even though the death of Lazarus wasn't what God initially would have wanted for His dear friend, God *always* has a plan. In response to the miracle of Jesus raising Lazarus from the dead, John tells us, "So then, many of the people who were with Mary believed in Jesus when they saw this

happen" (v. 45). Hallelujah! That is a miracle within itself. I'm sure not only souls were saved that day, but just imagine if you were Mary or Martha. They were in much grief because of their loss, but I think it's safe to say that both their faith and relationships with Jesus deepened tremendously when Jesus showed up and performed a miracle of restoration. And who knows what other life-changing revelations God was able to reveal to them in that time of suffering and rejoicing?

On a more personal level, the healing I have received in life, first and foremost, followed the instruction of God calling me toward a relationship with Him. I have believed in God from a very young age, but because I did not have a relationship with Him, most of my young-adult life was filled with bad decisions, promiscuity, alcohol, partying, toxic relationships, and everything else you can think of that falls into that category. Just like the young woman in this chapter's poem, it wasn't until I began encountering Jesus that a lot of the hurt and trauma in my life began breaking off. I was able to replace the lies of what I believed about myself, others, God, and life in general, with the truth of Scripture. I began hearing God's voice deep within my spirit. I began to grow a desire for godly things, such as serving the church and the community, sexual purity, sobriety, God's will and purpose over my life, and how to have healthy relationships and friendships.

Allow me to say that adopting the truth of Scripture as our minds are in a renewal process is only the first step. We must be intentional about maintaining and practicing the Truth of Scripture when facing both the joys and adver-

sities of life. Life will never be perfect, but when
applied, the truths that live within the word of God
will make life and facing troubles so much easier
to endure. I sometimes have this thought that I
don't know where I would be without having an
awareness of God's love for me, especially when I
don't always necessarily feel loved by others. I've
been through a few painful breakups, but there
was one specifically that was probably the most
devastating because it with someone who I felt
was my soulmate and my best friend. Although
he is a wonderful person and ended the relationship
for a fairly understandable reason, I felt many different
emotions throughout what seemed like a never-ending
healing process. Rejection, disappointment, inadequacy,
anxiety, hopelessness, depression, and unforgiveness all
attempted to steal my peace and joy for about a year. I
asked and sometimes even begged God to heal my heart
almost every day during that time. And I'm grateful that
in my darkest days, the Holy Spirit never failed to comfort
me. I was also blessed with much-needed support from a
select few of carefully chosen and trusted family members,
fellow Christians, mentors, and pastors; but for quite some
time, somewhere under that comfort was still a heart in
need of mending.

 One weekend, I was visiting a city I had lived in for a few
years before moving back to my hometown, and a friend
invited me to church. I initially declined since I had already
gone to a different church earlier that morning; and with
this church being across town, I knew I would arrive late.

And I'm grateful that in my darkest days, the Holy Spirit never failed to comfort me.

But the more I tried to justify why I didn't need to attend, the more I felt led to—so I was obedient. The sermon hadn't started yet upon my arrival, but even walking into the worship and opening prayer, I was already bawling my eyes out as I felt burden and emotional pain leave my body. The supernatural peace of God flooded me, and I left that service feeling as though I had just experienced a miracle of healing. To be honest, I didn't feel 100 percent healed, but I felt tremendously better—almost like a heavy metal weight was lifted off me. In that one moment, my tears of pain suddenly turned into tears of gratitude. For the first time, I was so relieved and hopeful that I would be able to soon have the full healing I had been praying for.

About three to four months later, I was still not completely healed, although God has brought me far. I remember being in prayer and hearing God tell me to begin fasting and praying. He instructed me to fast all solid food on both Sunday and Monday of each week for one month, and to fast from certain habits irrelevant to food for the entire month. These "habits" can be different for everyone and could generally include things such as not watching television, limiting social media use, not drinking alcohol, and pretty much anything that can be done or consumed that could interfere with or hinder your time and communication with God. As I was in prayer that following Monday, God asked me at one point to dig deeper. He asked me to vocalize my hurt, my fears, and my deepest pain that my heart was experiencing pertaining to my breakup. In tears, I prayed, "Lord, my deepest pain is that 'so-and-so' is going to one day choose someone to

be his wife, and that person will probably not be me. I genuinely did everything I could do to be who he needed, yet here I am—rejected, still needing to fully forgive, and jealous of a woman who isn't even in his life yet. Heal me from this pain, Father! Deliver me!"

At that moment, I was flooded by God's supernatural peace. I felt the presence of God, and yet again, it felt as though a heavy burden was lifted off me. I suddenly no longer felt that deep-rooted pain I had felt just moments before. In that moment, God reminded me of things that I needed to be reminded of, such as:

His love, power, and desire to heal;

His faithfulness, and to trust Him no matter what happens;

The significance and effectiveness of vulnerability while in prayer;

The significance and effectiveness of obedience to His instruction.

As I was obedient to God's instruction to fast and pray, as well as to be vulnerable enough to "dig deeper" to express my deepest hurts and pain, He was again faithful to continue His healing within me. Of course He knows every pain we feel, not only because He is all-knowing, but because He, as Jesus, experienced firsthand every type of pain we feel. But God wants to connect with us in specific places and specific ways so that as we cry out to Him, only *He* can be given credit and glorified for our

healing. I also believe in the power of vocalizing words, Scripture, and prayer. I believe that because Satan can also hear our words, he is best removed from our circumstances, sin, and thoughts when he hears us declaring and decreeing the truth of the Word and our love for God. The more that we do, the more he will flee—leaving room for a deeper presence of God to saturate us and provide us with everything we need.

Listen to His voice and respond accordingly so you, too, can receive your miracle.

That same night, God also took me to the story of Jesus calming the storm in Matthew 8. Verses 25-26 say, "The disciples went and woke him up, shouting, 'Lord, save us! We're going to drown!' Jesus responded, 'Why are you afraid? You have so little faith!' Then he got up and rebuked the wind and waves, and suddenly there was a great calm." As I begged God to save me from my pain, He questioned my faith just as He questioned the faith of His disciples—and rightfully so. I was reminded that He has never failed me and He never will. As His daughter, I have literally been given the honor of being able to place my trust into a perfect, good, and faithful God. And because of that, I can have peace through every storm—and so can you!

I share that story to say this: healing is a process, but God has the power and the desire to heal. He wants to heal *you*. I understand that you may have days of hopelessness; days where you can't get out of bed; days where you feel as though you will never get past what you are going through. Sister, I've been there! But I promise it gets easier. You must do your best to shift your focus from the thoughts that

make you sad, worried, and anxious, toward what God is doing in your process. And while He's doing what *He* needs to do on your behalf, I encourage you to sit in prayer and listen to God's instruction. Listen to His voice and respond accordingly so you, too, can receive your miracle.

The Prayer

Dear Heavenly Father,

I thank you for being a God who heals physical pain, illness and infirmity, spiritual brokenness, and the deep, emotional, and shattering pain of a broken heart. Father, I pray over every beautiful soul reading this right now, God; that Your healing power covers her in every way needed. I pray over your daughter's body, Father. If she has made a decision to accept you as her Lord and Savior, we can acknowledge that you dwell within her and that you truly want to dwell within a temple that is pure, whole, and renewed.

I thank you, Father, for giving her the strength to get this far, having to face such a dark world at times, but I recognize the healing power you have over her in Jesus's Name. I declare and decree that her body is completely healed in Jesus's Name, that her mind is renewed in

order to completely align with the truth of your Word and your will over her. I pray that she encounters your love so deeply that she is given a new heart to replace the pieces that have shattered. I pray that she has the wisdom to face any decisions with a godly mindset that may contribute towards how she manages her health, whether it's during a process of treatment, for preventative measures, or to make good decisions that align with your will over her life.

I pray that she is able to overcome traumatic experiences and even any of her own regrets. I pray that you teach her how to forgive others and herself. Thank you for protecting her, for carrying her through some of the toughest seasons of her life, and for helping her face past hurts in ways that allow her to find more healing than she ever has before.

I pray this prayer in the Name of Jesus,
Amen.

The Practice

Prayerfully read over these questions and begin to answer them as honestly as you can.

1. What are some things or areas in my life I need healing from? Since God is a Healer, am I willing to begin finding more ways to build my relationship with God so that I may be able to better find healing in these areas?

2. I know I'm not perfect, and I accept that. But in what ways can I challenge myself to be more obedient so that I can experience the love of God through His healing power, whether it's a process of healing or in some cases a miracle?

3. After taking time to self-reflect and pray, do I consider
 myself a person who runs from my traumatic expe-
 riences, problems, uncomfortable situations, and/
 or people I need to forgive? Who or what things do I
 need to face and deal with where God can help me find
 healing and victory?

God Is Lover

*We know how much God loves us, and we have
put our trust in his love. God is love, and all who
live in love live in God, and God lives in them.*

— 1 JOHN 4:16

The Poem

"Wedding Day"

BY CASEY CASSADY & JESSIE MC BARROW (AKA JWVE)

It's her wedding day.
She gets to marry the love of her life.
In her bridal gown stitched with lace,
She's led down a courtyard of tile
to wife a bridegroom who's grace—
was set upon her, from before the day she was born

and through her gratefulness
she was no longer torn.

⁓

It may have taken a while, but she's here.
Her timing is now;
where she will return the commitment
of a life-promised vow.

Her new identity establishes
and her past diminishes.
She's beautifully becoming.

As she stands on a platform of victory,
her defeat and fear finishes.

As she begins to believe that she's
a great deal of something.

⁓

She knows that her commitment
cannot truly change the world,
if she is afraid to love.

So her blood-dipped feet take
one giant step towards Jesus,
even though at times it's tough.

Through the realignment of her pride,
Her groom sees her dressed in white.

Her soul is cleansed to purity
—no longer including insecurity;
since she is now a bride.

Her bridal party of angelic chariots,
sounds the trumpets as she draws close.

She's ready to enter her life in "the new."

Heavenly doors swing open in a God-given vision;
she sees the aisles ladened with precious stones,

Each representing a sin that has been forgiven
as she reflects on how much she has grown.

And as she walks towards the altar,
to find such a gentle groom.

He holds her by His side each second,
to fill the void that's in the room.

And the layers of the veil that once
held her down so strong,

Were being lifted off her face,
so that His light could sing a song.

The Principle

God's love is something you must recognize if you have not yet done so. It is the reason that our omnipotent God is capable of being *everything you need*. Because of His unconditional and unchanging love for you, He is your Father, Son Jesus Christ, Holy Spirit, Savior, Creator, King, Healer, and so much more. When you are able to better understand how much He loves you, you will begin to love Him more. When you begin to love Him more, you will begin to serve Him more. When you begin to serve Him more, you will begin to love yourself more, because you will find yourself in obedience, making good decisions, using more wisdom, harvesting heavenly benefits of loving and serving others, and growing spiritually in your walk with Him.

And just like the poem in this chapter, God calls us to be His bride. Being a bride means that we are "the church" of Christ once we become a Christian. We begin to die to our flesh and live for Christ as developing ministers of the Gospel. Equally important, when we see ourselves as God's bride, the church, we can confidently know that we are deeply loved as much as a husband is called to love his wife. Ephesians 5:25–26 says, "For husbands, this means love your wives, just as Christ loved the church. He gave up his life for her, to make her holy and clean, washed by the cleansing of God's word." To me, this verse is a beautiful example of the love that God has for all of us. It is referring

to how God sent Jesus to die on a cross, so that we (the Church Christ loves) can be made holy and clean, and have God's Word to hold onto as we seek to live in righteousness founded upon first seeking and knowing the love of the God.

Another great example in Scripture that reflects the bride-Jesus relationship is Isaiah 54:4–6, which says:

———

Fear not; you will no longer live in shame. Don't be afraid; there is no more disgrace for you. You will no longer remember the shame of your youth and the sorrows of your widowhood. For your Creator will be your husband; the LORD of Heaven's Armies is his name! He is your Redeemer, the Holy One of Israel, the God of all the earth. For the LORD has called you back from your grief—as though you were a young wife abandoned by her husband," says your God.

———

These verses powerfully refer to someone who is not yet a "bride" of Jesus (or a part of the Church) as a widow. Just as the literal term of "widow" means to no longer have a husband, this verse demonstrates that although we may have not chosen to follow Jesus in the past, once we choose Him, our Creator is our (spiritual) husband who unconditionally loves and redeems us more than anyone else can.

Biblically, there are four types of love that exist: *storge* (familial), *philia* (friendship), *eros* (romantic), and *agape*

(the unconditional love of the Father). To even remotely understand the love of God, we must recognize and believe that His character is made up of agape love. Although we (as humans) should aim to love unconditionally, God is the truest example of unconditional love. His love expressed the ultimate sacrifice (John 3:16, Romans 5:8, 1 John 4:8-10), is unfailing (Exodus 20:6), wide, long, high, and deep (Ephesians 3:18), faithful and eternally enduring (Psalm 118:2, 136:14-20), patient, kind, humble, hopeful, and persistent (1 Corinthians 13:4-7), covers a multitude of sins (1 Peter 4:8), is perfect (1 John 4:18), and makes up the character of God (1 John 4:8, 16).

God will do what He can to reveal Himself without forcing the decision upon people to choose to love Him.

God's agape love means that nothing can separate you from His love (Romans 8:38). That means that no matter what you have done, no matter where you have been, how much you have sinned, how many times you have been rejected by others, or how imperfect you may feel, you are loved by God and He wants a relationship with you if He doesn't have one already. And if He does, He will continue to unconditionally love you, period.

God's agape love does not justify your sin, but it forgives your sin—no matter what. It gives you an opportunity to start new as the Holy Spirit guides you, while transforming your being and life. His love gives you an incentive to repent from your sin. The more you fall in love with Him (because of Him first and always loving you), your heart will begin to no longer desire the sin it once did. As you accept and experience the agape love of God, you will be left in awe

of how truly amazing and good God is. As I think about how God has always been at work in my circumstances, revealing Himself to me in prayer, working everything out for my good, holding me each time I cried, healing me each time I hurt...well, I could go on forever...I am able to testify to what the Bible says God's love is. I experience it every day, and am often reminded by reflecting on His past faithfulness to continue to expect His love to conquer and embrace everything I go through.

Something I think people often misunderstand about having a love-filled relationship with God is how or where to even begin. God will do what He can to reveal Himself without forcing the decision upon people to choose to love Him. Therefore, God may seem "far away" to someone if they have not yet been intentional and communicative with Him regarding their desire to have a relationship with Him. But because He has first chosen and loved His children since the beginning of time, He literally waits for them to respond in reciprocation. Once they do, they are able to experience His love, goodness, and even miracles in much more intimate, personal, and evident ways. James 4:8 says, "Come close to God, and God will come close to you." Like any relationship, the desire and willingness to have the relationship should be mutual; and the deeper the desire is and the more effort is placed into the commitment of being with the other person, the stronger the relationship grows.

I can remember the first time I genuinely had a conversation with God about Him transforming me and my life. I had not yet even really pinpointed at that time

that my relationship with Him was soon going to dramatically strengthen; but starting that day, the day I prayed for God's will and transformation over my life, I began to feel His presence and love much stronger around me. I was receiving compliments more often, having pleasant experiences with people at work, being gifted with little surprises here and there, and meeting divine contacts who God would use to lift my spirits or to answer my prayers. On one occasion, I was walking into work and a stranger who was walking in my direction stopped me. He got down on his knee and serenaded me with the chorus of "You Are So Beautiful." He then stood up, dusted off his jeans, told me to have a nice day, and walked away. A little odd? Sure. But I felt in my spirit that it was just one of the many ways God was trying to show me *His* love. Then, not even two weeks later, I was surrounded by a newly-found Christian community, where my entire life began to change. Mind you, I had not even known prior to that what it meant to have Christian friends. But here I was, in the midst of a God-transformation. And I can tell you from experience that as I continued to draw near to God, He met me exactly where I was and drew near to me. For one of the first times in my life, being rejected wasn't even an option or a thought that crossed His mind. He is my daddy, and His love isn't going anywhere.

I know of a ministry called "AGAPE" in Sacramento, California, that was founded in 2009 by two prophets from Ghana, Africa, who are brothers. I had the pleasure and honor of reciting some of my poetry in this book at their ministry's ten-year anniversary celebration. I have

also attended several of their Bible studies. (I moved to a different city so I can no longer go as often, sadly.) Trust me when I say that gathering with them and the rest of my brothers and sisters there was always very much filled with God's presence, love, wisdom, and truth. If any human being has an idea of what God's agape love is, I trust that these men do. When I asked one of them, Prophet Andorful Gaisie, how he defines "agape love," this is what he said:

> "Agape is the God-kind of love, as compared with others. It is unconstitutional and unconditional. Agape love also means embracing the love of God with all dimensions—such as the 'breadth, how big is it; length, how long is it; depth, how deep is it; and height, how high is it... and surpasses knowledge' (Ephesians 3:18-19)."

As we near the end of this book, I want to share a word of encouragement that I wrote and recited at a women's conference when the Director of the Women's Ministry asked me to "focus on the massive love of God." I feel as though it is relative to Prophet Andorful's perspective of agape love, and I hope it encourages you by describing some thoughts I have had about the love of God.

> When you look in the mirror, what do you see? I see strands of hair, numbered (Matthew 10:30). I see eyes, a nose, and a chin, that look just the way intended. I see a woman on a path, with a plan and a purpose. I see a world-changer, an atmosphere-shifter, all because of a baby in a manger, whose Father first said about each Beloved, "*I*

get her, so I'll gift her with all that she needs, so she can succeed, and so that she can live for Me."

You see, His love for you is *massive*. Massive means, "large and heavy or solid." His love for you is solid—it's tangible. You can grasp it; you can hold it. You can see it around you—in the beauty of the universe; in miracles, signs, and wonders. You can taste it in the word of God. You can hear it in His voice. You can smell it in His fragrance. You can feel it dwelling within you. Solid means, "firm and stable in shape." And the second definition I found for solid, was "Having *three* dimensions." So I have come to the conclusion that these three dimensions of the state of being *massive* are God the Father, God the Son, and God the Holy Spirit. And what are dimensions? Some examples of dimensions are width, length, height, and depth.

Today is the day that you choose God's definition over your identity rather than the definition the world attempts to place on you.

Ephesians 3:18-19 (AMP) says, "And may you be fully capable of comprehending with all the saints (God's people) the width and length and height and depth of His love [fully experiencing that amazing, endless love]; and [that you may come] to know [practically, through personal experience] the love of Christ which far surpasses [mere] knowledge [without experience], that you may be filled up [throughout your being] to all the fullness of God

[so that you may have the richest experience of God's presence in your lives, completely filled and flooded with God Himself].

We need to get this; for God, for ourselves, for our relationships, for our families, for the world, for our futures, and for the next generations. I think the hardest part of understanding the unconditional love of God, is that so often we are exposed to the conditional. So often, we have had to face people who don't know how to forgive, people who have at one time trusted someone else a little too much. So many times, we've had to face people who said what she said and did what she did because she wanted to fit in just as bad as you did; or because they were lost deep in sin or addiction; or because they really just didn't know any better.

But today is the day that you choose God's definition over your identity rather than the definition the world attempts to place on you. Today is the day that you choose God's vision for you, over your life. And today is the day that you choose the love of God, rather than the love of lies, the love of toxicity, and the love of the world. You are in the world, but you are not of the world. In fact, because we are in Christ, we have authority over the world. How can we let so much of what we have authority over define us? What defines us? What leads us? What inspires

us? What heals us? What provides for us? What saves us? What befriends us? What understands us? What holds us tight and literally will never let go? The massive love of our Father—the length, the width, the depth, and the height of a solid, stable, tangible, unconditional, *massive* love. Call to God as a lover calls to their love. Allow yourself to live and love again. You will find new levels of freedom awaiting you when you release yourself to the love of God. Once you do, you will experience true love, freedom, hope, faith, and trust.

The Prayer

Dear Heavenly Father,

I pray over the beautiful soul reading this right now. As this book comes to an end, I pray over her mind, body, and soul. I pray over her wellbeing, her health, her life as it is now, and her destiny. I pray over how she measures her worth, that your love seeps deeper and deeper into her heart. She is learning to receive your love but does not always know how. If she does not yet fully know you Lord, hold her precious hands and help her allow you into her heart. You truly love everything about who she is in Christ,

even if not everyone in her past has. Show her more of what your unconditional love looks like and how it applies to her being. Meet her where she is, touch her, heal her, and completely restore any brokenness that lingers inside of her. Restore and renew her mind and her temple. Allow her to love herself and others more than she ever has before, by first growing in you, learning about who you are as God and your love for her. Show her what it's like to be a bride walking down the aisle in a tiled courtroom, crushing the enemy under her feet on the way, and meeting you at the altar.

Thank you, Father, for your daughter, and thank you for fulfilling every promise and prophesy over her life as she steps into a new Christ-given identity. I pray that through her identity in you, she finds complete healing, hope, and wholeness so that she may live in your purpose. I plead the blood of Jesus over your daughter today, as she is purified in your blood on the cross. She is now as white as snow. May she love and serve you to the capacity within her, and may she experience a shift through a deliverance of her past as she is stepping into her future.

I pray this prayer in Jesus's Name,

Amen.

The Practice

Prayerfully read over these questions and begin to answer them as honestly as you can.

1. What do I think of when I think of the agape love of God and the love that God has for me?

2. Do I feel loved by God, even when I think about or experience not feeling loved by other people? In what ways can I be intentional about seeking God's perfect love?

3. Why would God not love me? (List any reasons you can
 think of and then cross them off and tell yourself that
 God loves you anyway!)

4. In what ways can I better show my love for God, love for
 myself, and love for others? When will I start practicing
 love in ways that I never have before?

God Is the Beginning
...and the End

*I am the Alpha and the Omega, the First and
the Last, the Beginning and the End.*

— REVELATION 22:13

As this book comes to an end, I want to emphasize that
God is not limited to the roles or relationships I chose to
write about in this book. He is truly so much more! I chose
them prayerfully and specifically because, one, I had to
start somewhere (with the intention of writing more books
to follow); and two, because I felt as though they describe
who He really is. From them, I hope you are able to build
a solid foundation in your understanding of Christ so you
can find hope, healing, and wholeness, as well as your
identity in Him. May your relationship with Him continue
to develop at a deeper level.

I truly hope and pray that you are able to walk away from this book confident in the fact that you are never alone in your circumstances, that Christ has a special plan and purpose for your life, and that God loves you and wants the best for you no matter your past trauma or current struggles. I want you to walk away from this book loving yourself more as you recognize your worth and as you make intentional decisions that enable you to co-partner with God to live in purpose and the abundant life He promises you. I want you to be excited for your future as you press on in your journey worried about nothing, but finding supernatural peace by being prayerful, with thankfulness, about everything. (Philippians 4:6–7)

I want you to better recognize that God sent Jesus to die on a cross for you so that you may be given a choice and a chance to have a relationship with Him, as well as eternal life in Heaven. (John 3:16) I want you to have recognized that YOU, beloved, are a beautiful soul and have been created perfectly in God's image, with no blemish in His sight whatsoever. (Genesis 1:27 and Ephesians 5:27) Additionally, I want you to know that it IS absolutely possible to go from being *chained* to *changed*, but only Christ can fully and efficiently do this for you. Psalm 107:14 (TPT) says this:

———◦———

"His light broke through the darkness and he
led us out in freedom from death's dark shadow
and snapped every one of our chains."

———◦———

Mighty daughter of God, are you ready for freedom?

Lastly, I want to close with a prophetic word from the Holy Spirit over you. The Lord is saying that as His daughter, you are becoming more empowered. He knows exactly what you need at this point in your life, and He is providing that *and more* for you as you find a genuine desire and fulfillment in being used for the Heavenly Kingdom through the power of God. As you have and continue to transform into a warrior of Christ, He is preparing you for anything and everything you may face in the future. This world is a constant spiritual war zone; but as you recognize the weapons God equips you with to face each battle, you will find yourself with victories you never thought possible. Ungodly spirits, habits, thoughts, and fears have broken off of you in Jesus's Name, and are being replaced with new levels of recognition of your authority and identity in Him, and with supernatural peace, healing, and power.

You will begin to now experience long periods of time with having no worry, no anxiety, no stress, and no feelings of being overwhelmed. God is directly imparting deep levels of freedom upon you. I declare and decree that as you fall in love with Jesus, because of His love for you, you will also fall more in love with who He has created you to be. Self-judgment, self-condemnation, and self-hatred are no longer acceptable for you. You must see yourself in

the way our perfect Father sees you. Hear Him saying to you these precious words:

"Daughter, I know it can be scary
but *do not fear*. Follow where I lead you.
Let's do this *together*. I define who you are
and what you are capable of, through Me.
There is no limit on what we will
get through and what we will accomplish,
because you can do all things through
Me as I strengthen and empower you.

You are no longer chained by this broken
world but are *changed* because of what
I have done for you on a cross.

See, speak, hear, taste, and smell
my glory as you live with me and for me
in sweet, divine freedom.

I unconditionally love you
forever, and ever."

Amen and Amen

ABOUT THE AUTHOR

Casey Cassady

CASEY CASSADY was born and raised in Fresno, California. She earned her Bachelor of Arts degree in Communication from CSU Fresno, as well as an Emergency Medical Technician certification from Fresno City College. These two programs together led her into the medical field, which she still works in today. In 2015, Casey relocated to Sacramento, California, where she re-dedicated her life to Christ and began an intimate spiritual journey that she never knew to be possible. As God continued to develop her in her relationship with Him, Casey found herself passionate about her newfound calling toward ministry. She quickly became involved and served in several different ministries, such as Young Adults, Evangelism, Deliverance, Prophetic, and Women's Ministry.

Inspired by her leadership experience, as well as meeting divine contacts who God used to encourage and challenge her in her calling, Casey began writing "*Chain-ged*," so that God could use her to help others through her poetical testimony, wisdom, and gift of exhortation. Casey has also began working with a music and video producer to create spoken word video content for some of the poetry in this book (which you can find on her YouTube page). Casey is also currently pursuing a Master's degree of Christian Ministry with Oral Roberts University. She plans and prays for "*Chain-ged*" to be the first book of many, as a part of her future "*Finding Freedom in Christ*" book and poetry series.

"As I reflect back to who I was before I wholeheartedly gave my life to Christ, and even in my more recent painful seasons, I know that even I needed someone to tell me the things that I have written in this book earlier on in my life. I hope that by being obedient to the godly assignment of writing this book, you are given everything you need in order to powerfully find hope, healing, wholeness, identity, transformation, and purpose in Christ."
— Casey Cassady

To connect with Casey, you can find her at:

info.caseycassady@gmail.com

@findingfreedominchrist
@caseymaecassady

facebook.com/findingfreedominchristbook

youtube.com/channel/UCeWh0JG0VIIG29os7rm6IaQ

NOTES

NOTES

CPSIA information can be obtained
at www.ICGtesting.com
Printed in the USA
LVHW081040140521
687441LV00020B/301/J